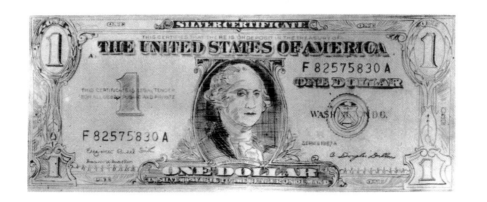

Andy Warhol

Great Modern Masters

Warhol

General Editor: José María Faerna

Translated from the Spanish by Alberto Curotto

CAMEO/ABRAMS

HARRY N. ABRAMS, INC., PUBLISHERS

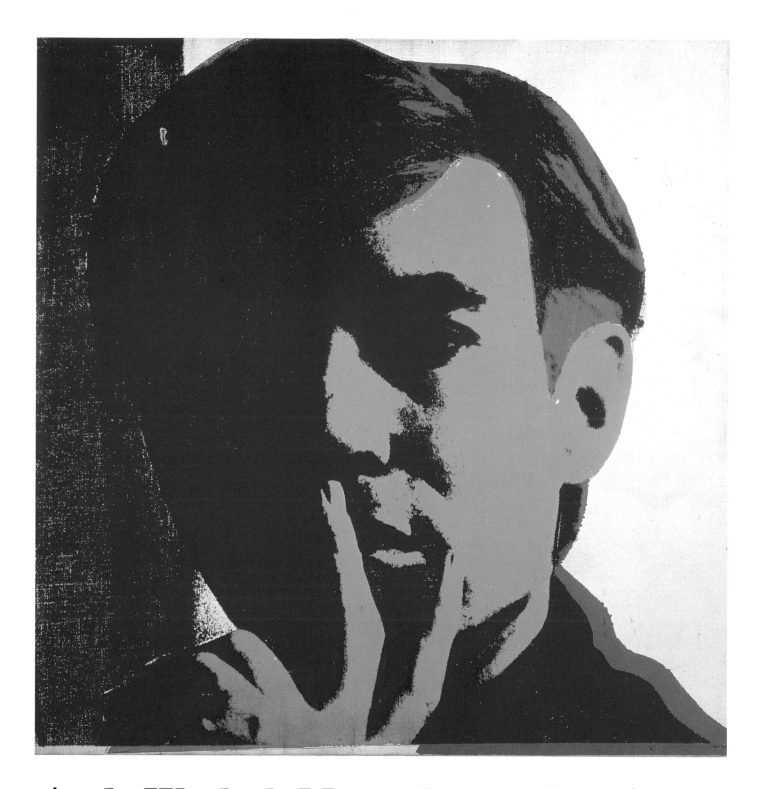

Andy Warhol: More than a Pop Artist

Above:
Self-Portrait, *1966. Acrylic paint
and silkscreen ink on canvas,
22 × 22″ (55.9 × 55.9 cm)*

Andy Warhol has been called a mirror of his age. And indeed, Warhol's oeuvre—from his early graphic work to his exaltation of such commonplace items as Campbell's Soup cans to his celebrity to his seven-hour-long film of the Empire State Building—closely reflects the America of his time. For the artist's critics, his work constitutes the quintessential paradigm of the frivolousness and banality of that period. To be sure, Warhol intentionally cultivated a somewhat trivial image, one that he reinforced through many oft-quoted maxims, perhaps most notably his assertion that

"If you want to know all about Andy Warhol just look at the surface: of my paintings and films and me, and there I am. There's nothing behind it." Yet few artists have had a greater impact on the world of art, and even fewer have ever achieved the kind of personal celebrity that Warhol enjoyed.

Indeed, Andy Warhol can be viewed as the perfect embodiment of the American Dream, the self-made man who successfully overcomes an impoverished upbringing to become a millionaire. Warhol personifies a new type of star, at once creator, producer, actor, and—last but not least—brilliant businessman. In fact, for Warhol, "Being good in business is the most fascinating kind of art," according to another of his famous aphorisms.

Pop Art *vs.* Abstract Expressionism

Andy Warhol almost single-handedly modernized our aesthetic tradition. As far as both themes and mediums are concerned, Warhol was at the origin, or at least he became a symbol of a momentous transformation in contemporary painting. Even without almost ever resorting to ready-mades—he did indeed sign some cans of Campbell's Soup—Warhol challenged, more than any other Pop artist, the traditional conventions pertaining to the uniqueness, authenticity, and authorship of the work of art. He completed the process of dissolution of easel painting that had been initiated by the Abstract Expressionists, whose break with tradition was admittedly not as radical as Warhol's. Unlike such idealistic artists as Jackson Pollock, Franz Kline, Mark Rothko, or Barnett Newman, who had a profound veneration for the innermost world of consciousness, Warhol was obsessed by concreteness, the material world, that is, visible and tangible objects.

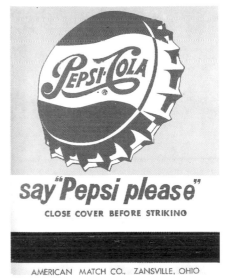

Fabis Statue of Liberty, *1986. Here, by bringing together into a single image a brand of cookies and one of the most distinctive emblems of American civilization, Warhol simultaneously presents two thematic veins that persist throughout his entire production.*

Artistic Piracy

Over and above his activity as an artist, Warhol's boldness and provocativeness were conspicuous traits of his personal life as well: his aspect and behavior never failed to clash drastically with the image of masculinity that his predecessors had carefully fostered. Moreover, unlike them, Warhol consciously attempted to correct, so to speak, the universals of Abstract Expressionism and to "re-Americanize" the art of the United States. In fact, like the phenomenon of Pop art itself, the themes of his work were always thoroughly American.

Pop artists never formed a coherent movement, nor did they issue manifestos or joint formal announcements, and in spite of their common fondness for popular imagery and a shared predilection for commercial artistic techniques, their respective styles were altogether distinct and unmistakable. When looking at Pop painting, one immediately realizes that its themes are hardly, if ever, original—they are not the product, that is, of the artist's creative imagination. No longer an original creator, the Pop artist merely observes and selects. Pop art is a form of artistic piracy, so to speak. Its thematic choices are based on a repertoire of previously processed images: not a live girl, but a pinup from a magazine; not a real can or package, but the printed ad for a can or a package. Building on the same symbols and themes, Warhol bypassed entirely any type of painterly packaging: instead of presenting merchandise as a sublimated theme, he

Close Cover Before Striking (Pepsi-Cola), *1962. Warhol has transformed a matchbox into a painterly work simply by enlarging its size, a technique often adopted by Pop artists, who typically turned their attention to objects of mass consumption.*

Jasper Johns, Painted Bronze, *1960. A precursor of Warhol's soup cans, which he began painting two years after this work by Johns.*

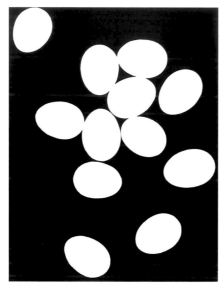

Egg Painting, *1982. The Egg Paintings are one of a number of series of virtually abstract paintings that Warhol undertook in the 1980s and which are quite unlike the rest of his oeuvre.*

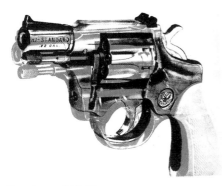

Revolver, *1982. Warhol's personal fascination with death-related objects and events appears in most of his work.*

rendered it with the same crude and exact makeup of advertising; instead of using his own expressive and creative force, he offered a plain reproduction; instead of an individual style, he resorted to the impersonal process of printing.

An Art for All

Warhol's aim was to bridge the gap between avant-garde artists and the public. The common people, not the intellectual elite, are the intended recipients of his work. Pop art was meant for everybody, not only for the select few. Warhol wanted to put an end to the stereotype of the artist in an ivory tower; he chose instead to descend into the streets, exhibit his work in shop windows, and appropriate the most typical products of mass consumption. Hence the familiarity of his art; like Pop art in its original formulation, it attempts to react against those elite viewers who had tried to impose one single form of art—and one type of response to it—to the exclusion of all others. In some instances, however, the viewer's response may be different from what Warhol intended, since the layperson is not always likely to grasp the value of his oeuvre. One of the principal characteristics of the Pop artist's work is its transience: as soon as its themes are no longer recognizable for posterity, its interest will for the most part disappear. The novelty and originality of Warhol's art is firmly rooted in its choice of pictorial contents, which, for future generations of viewers, is bound to lose its primitive sense of radical desacralization of traditional myths.

Midas's Touch

His transgressive attitude notwithstanding, Warhol managed to gain wide public acceptance and, toward the end of his career, as Benjamin H. D. Buchloh has suggested, he had apparently succeeded in reconciling "the two poles of modernistic dialectic, the department store and the museum." (Indeed, Warhol once claimed that "department stores are kind of like museums.") In 1986, while his works hung in important collections alongside great masterpieces from the past, the artist offered a portrait sitting for sale at 35,000 dollars in the Christmas issue of the Neiman-Marcus mail-order catalog. Like King Midas, Warhol appears to have had the power of turning to gold all that he touched. Even the most insignificant, trite, and cheap object could potentially be converted into a work of art. In modern times, mankind in general and artists in particular appear to have been absorbed by the external world, pushing the inner world of the self into the background. Contemporary society seems fascinated by exactly this type of cynical and transgressive artist glorified by the media. There appears to be a widespread worship accorded to the artist as businessperson or the businessperson as artist who is able to equate consumerism with a form of egalitarianism: "What's great about this country is that America started the tradition where the richest consumers buy essentially the same things as the poorest. You can be watching TV and see Coca-Cola, and you can know that the President drinks Coke, Liz Taylor drinks Coke, and just think, you can drink Coke too. A Coke is a Coke and no amount of money can get you a better Coke than the one the bum on the corner is drinking. All the Cokes are the same and all the Cokes are good. Liz Taylor knows it, the President knows it, the bum knows it, and you know it."

Andy Warhol / 1928–1987

There exists a wealth of information about Andy Warhol, though much of it is contradictory. The artist himself obsessively documented his own existence with a profusion of data and photographs but often omitted or changed facts as he saw fit. The frequently disputed year of his birth is 1928, when, on August 6, he was born Andrew Warhola in Pittsburgh, the youngest of four children of Ondrej and Julia Warhola (the oldest, a girl, died in infancy), Czechoslovakian immigrants who had settled in the Pennsylvanian city. His mother—who lived with him for many years and even collaborated on some of his works—figured prominently in Warhol's childhood recollections. After the death of his father—a coal mine worker—in 1942, the Warholas led an existence of near indigence.

From Andrew to Andy

In 1945 Warhol entered the Carnegie Institute of Technology, where he majored in painting and design and received a rather unconventional artistic education. While in school, he worked part-time as a window dresser for a number of department stores, making his earliest contacts with what would become the principal environment of his activity, namely the world of consumption and advertising. In 1948–49 he submitted, as an official entry at the annual show of the Associated Artists of Pittsburgh, his painting *The Broad Gave Me My Face, But I Can Pick My Own Nose*, which, after being turned down by the admission committee, was eventually shown in some alternative exhibition space. Even as a boy, Warhol had been intrigued by the possibility of changing his identity, and that work, despite the obvious humor of the title, was evidence of how deeply dissatisfied he was with his own appearance. (In 1950 Warhol began wearing the first of his trademark wigs, and, in 1957, he elected to undergo plastic surgery.)

In the summer of 1949, after graduating from the Carnegie Institute of Technology, Warhol left Pittsburgh for New York in the company of his friend the artist Philip Pearlstein. The move marked the starting point of an entirely new existence: Andrew Warhola died and from his ashes Andy Warhol rose. In New York, he worked as a free-lance commercial artist for such well-known magazines as *Glamour*, *Vogue*, *The New Yorker*, and *Harper's Bazaar*; for retail stores such as Tiffany & Co., Bergdorf Goodman, and Bonwit Teller; and, most notably, for the I. Miller shoe company. Thus he achieved a long-coveted financial security. His work began to obtain a certain recognition, and in 1952 his first solo exhibition, "Andy Warhol: Fifteen Drawings Based on the Writings of Truman Capote," was held at an art gallery in Manhattan. This event marked the beginning of a countless series of rewards, and gradually his dreams began to come true.

A Return to Painting

After securing a formidable reputation in the advertising world as an illustrator, Warhol in 1960 undertook to change his professional identity from that of commercial artist to practitioner of the fine arts. Among his first efforts upon his return to painting were works in oil with comic strip characters as their theme. To his amazement, in 1961 he found out that another young artist, Roy Lichtenstein, had been working on the same idea, with more successful results. Warhol quickly abandoned his comic-strip paintings.

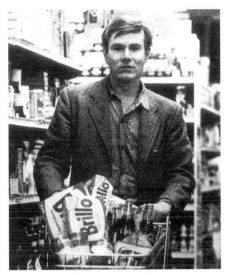

Andy Warhol shopping in a supermarket in 1964. The same year he undertook the series of silkscreens of grocery cartons, including some identical to the Brillo boxes visible in his cart.

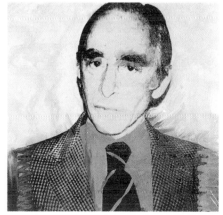

Leo Castelli, 1975. Castelli, one of America's most influential art dealers, played a prominent role in promoting Warhol's work and Pop art in general, both in the United States and in Europe.

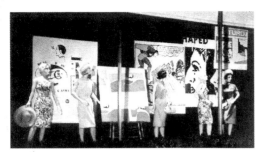

In 1961 Warhol used five of his own paintings as backdrop for a window display at the Bonwit Teller department store in New York. Art and consumption were always two closely linked concepts in the work of the artist.

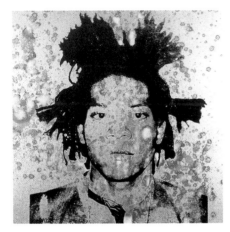

Jean-Michel Basquiat, c. 1982. At the time of this portrait, Basquiat was not yet himself world famous as a painter but was simply one of the many figures who made up the peculiar Warholian universe of the Factory. In 1984 he collaborated with Warhol on a series of silkscreens and another of paintings.

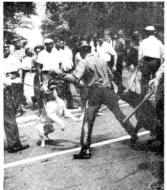

Many of the works Warhol based on topical events issued directly from press photographs. This image was the source of the series Race Riots.

Just as Warhol's output as an illustrator would eventually infiltrate the art of the avant-garde—with which, unlike the average graphic artist, he was very familiar—his paintings were deeply influenced by such commercial techniques as mass production. In 1961, five of his cartoon paintings were hung as a sort of backdrop in a window display at the Bonwit Teller department store. The following year saw the emergence of some of Warhol's most recognizable themes: the Campbell's Soup cans and the Disasters, as well as the portraits of Elvis Presley and Marilyn Monroe, which marked the beginning of his experimentation with screen-printing techniques.

At the same time, Warhol was developing a growing interest in films, and in 1963—the year of *Sleep*—he tried his hand at moviemaking. For Warhol, the chief interest of cinema, as well as of photography, lay in its immediacy. Moreover, both techniques required only a minimal intervention on the part of the artist: the real work was done by the camera and the subject.

The Factory

In 1963, Warhol moved his studio to 231 East 47th Street, in what would soon become known as the Factory. Warhol's metamorphosis, and its significance for the history of art, was spectacular: from individual independent artist to head of a factory of art-workers who were able to churn out works as from an assembly line. "The reason I'm painting this way," he once said, "is that I want to be a machine." Aided by his assistants and associates, Warhol proceeded to gather around himself a sort of Renaissance court that enabled him to keep up the high output necessary to meet his financial needs. Nonetheless he always remained open to outside suggestions.

More than a mere workplace, the Factory was transformed by theatrical lighting designer Billy Name into a sort of all-encompassing fantasy world of aluminum foil and metallic silver paint. This truly amazing place was visited by all manners of people, from students and young artists to actors, rock stars, and transvestites, and soon the Factory became one of the trendiest gathering places for the "in" crowd and the center of New York's cultural universe.

The year 1966 marked the beginning of his close collaboration with the musical group The Velvet Underground, as the two staged multimedia "happenings" in New York and California. Two years later, the radical feminist Valerie Solanas shot the artist in an assassination attempt. Severely wounded by the gunshot, which ricocheted in his body, Warhol spent almost two months in the hospital.

A Star is Born

After the 1960s Warhol's output skyrocketed with frequent incursions into virtually every artistic field. Soon his own celebrity began to eclipse that of his portrait subjects, as he traveled in the company of socialites, movie stars, and rock-and-roll stars. Warhol's work from the 1970s and 1980s was of a much more painterly nature than before; his brushwork had become more expressive and visually more complex, adding a certain vitality to the coldness of the silkscreen medium.

His career experienced one final major twist as he turned toward the most abstract works of his entire production with such series as his Oxidation Paintings, Shadows, Egg Paintings, and Threads. On February 22, 1987, following the surgical removal of his gallbladder, Warhol died in a New York hospital. His death marked the end not only of a great artist but of an era. The funeral was held in the artist's native Pittsburgh.

Plates

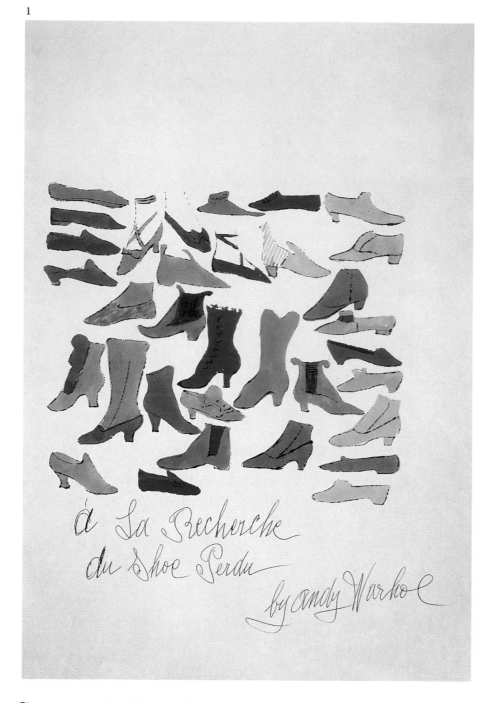

1 A la Recherche du Shoe Perdu, *1955.*
Warhol invented the game—with clearly
fetishist connotations—of identifying a
specific item of footwear with the person
wearing it. In Warhol's work, shoes—a sort
of pedestal used by all mortals alike—are
no longer just another wardrobe article or
an abstract pictorial motif, but an
extension or appendage of the individual
in their own right. The clumsy manual
quality of the image is underscored by the
childlike handwriting of the text and
signature, probably traced by the artist's
mother.

Success in New York

Warhol's first assignment as a commercial artist in New York was a series of illustrations accompanying an article titled "Success Is a Job in New York," which was published in the September 1949 issue of *Glamour*. After this initial success, more jobs flowed in. Shoes first appeared as a theme in Warhol's production in 1955—as illustrations for a book titled *A la Recherche du Shoe Perdu*—and proceeded to become the most readily identifiable motif of Warhol's early work. A year later, the artist launched what would become his most successful series: the Golden Slippers—realized, for the most part, as gold-leaf collages—were associated with a variety of movie stars and other celebrities. By 1959 Warhol had become an established and celebrated commercial artist. One of the main characteristics of his work from this period was the use of the so-called blotted-line technique, which would become one of his most recognizable trademarks. Warhol had accidentally discovered this technique as a student when, by chance, he applied some blotting paper onto one of his ink drawings: the resulting impression fascinated him because it looked like a reproduction. A primitive form of printing, this technique enabled him to hasten the demise of the traditional distinction between an original and its copies.

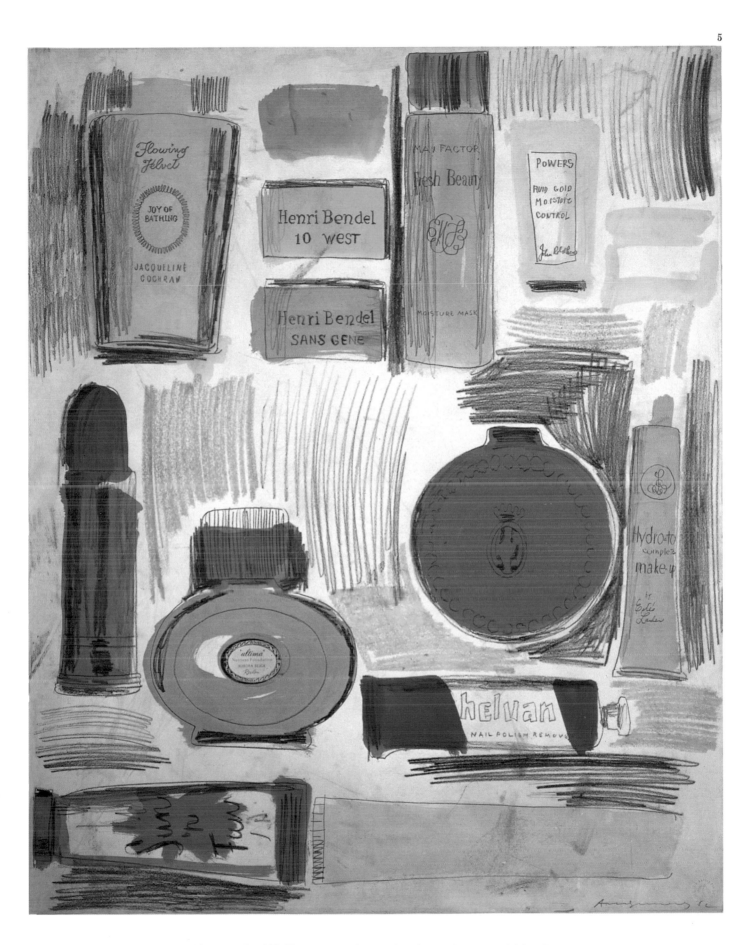

5 Untitled (Cosmetics), *1962. Warhol—one of whose favorite pastimes was visiting department stores—was given to buying large quantities of products of mass consumption, such as bottles of perfume, jars of lotion, shoes, and other items, then using them to create models like this one, which has the unfinished quality of a sketch for an ad for women's cosmetics.*

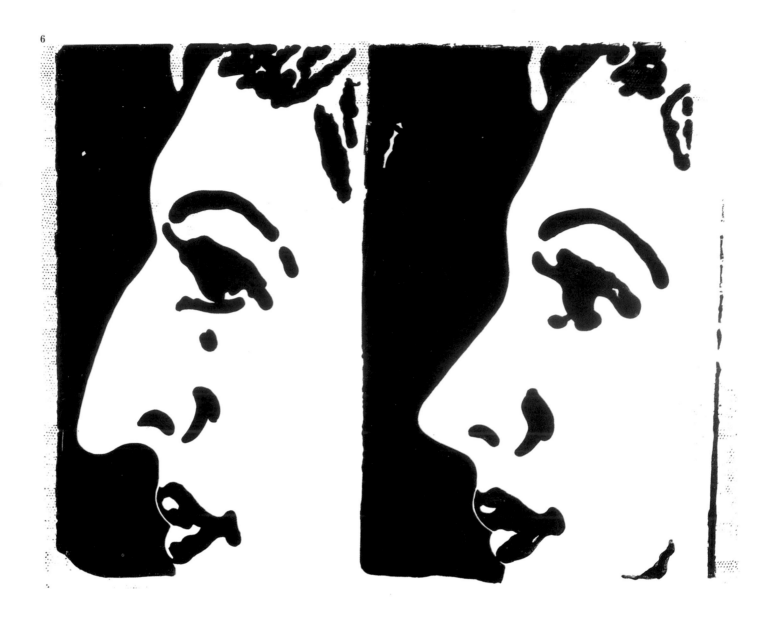

Art as Formula

Warhol's career underwent a fundamental change when, in the early 1960s, he decided to give up on his activity as a commercial illustrator to devote himself entirely to the fine arts. For the most part, his works were painted by hand with acrylic paint diluted in water, which allowed them to dry in a short time. As a rule, their themes proceeded from the world of advertising that he recently abandoned and from the mass media. Warhol often led the viewing public to believe that anybody could execute his works and that, as an artist, he acted merely as an intermediary. The paintings of the 1962 series titled *Do It Yourself*—drawing kits for amateurs—are unmistakable evidence of his notion of art as formula, a recipe, as it were, complete with a set of detailed step-by-step instructions. No need to take any chances: just pick your theme, blend in the ingredients in the recommended quantity, and you are guaranteed to succeed. "When I have to think about it," he maintained, "I know the picture is wrong. . . . Some people, they paint abstract, so they sit there thinking about it because thinking makes them feel they're doing something. But my thinking never makes me feel I'm doing anything."

6 Before and After, *1960. This work, along with* Advertisement, *was used as a background decoration of a window display at the Bonwit Teller department store in New York. Warhol closely imitates the images used in authentic ads of this type and limits his intervention to transferring them onto the canvas with ever-so-slight technical variations. The underlying idea—venting a personal complex of the artist—intimates the miraculous outcome of plastic surgery of the nose, which Warhol himself underwent in 1957. Both thematically and from a compositional point of view, this picture is at the origin of many of his later works.*

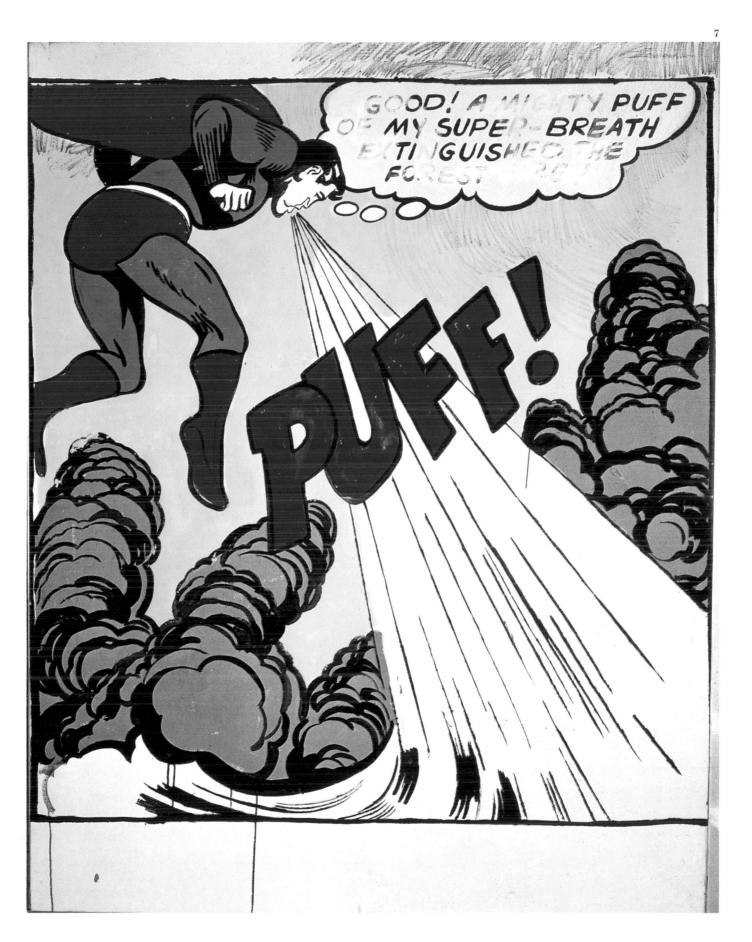

7 Superman, *1960. The subject of this painting was not particularly innovative, since his roommate Philip Pearlstein had already depicted the comic-book character in 1952, albeit with expressionistic tones, and later, between 1958 and 1961, the same theme was incorporated into Pop aesthetics by Jasper Johns, Robert Rauschenberg, and Roy Lichtenstein. Warhol may have abdicated iconographic originality but could not renounce a personal touch, as evinced by the traces of color crayon in the upper right corner.*

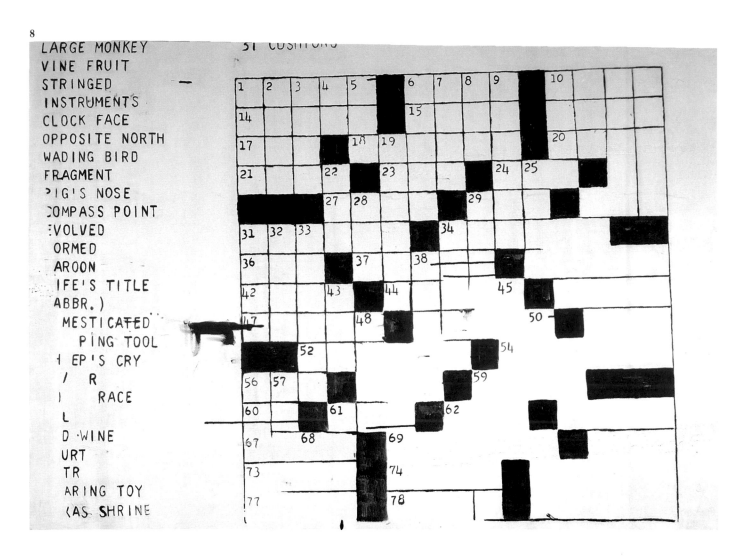

LARGE MONKEY
VINE FRUIT
STRINGED
INSTRUMENTS
CLOCK FACE
OPPOSITE NORTH
WADING BIRD
FRAGMENT
PIG'S NOSE
COMPASS POINT
EVOLVED
ORMED
AROON
IFE'S TITLE
ABBR.)
MESTICATED
PING TOOL
EP'S CRY
R
RACE
L
D WINE
URT
TR
ARING TOY
AS SHRINE

51 CUSHIONS

8 Crossword Puzzle, *1960. Here Warhol prods viewers to abandon their traditional passivity and take on an active role in the making of the work of art itself. The canvas—as Rauschenberg used to maintain—represents a horizontal plane, and that is just about the only position in which the puzzle can be solved. This particular work is also indebted to the famous paintings of numbers and letters that Johns produced in the mid-1950s.*

9 Telephone, *1961. In this painting Warhol has appropriated the taste of Francis Picabia and other Surrealist and Dadaist artists for machinery and mechanical parts endowed with sexual connotations. In spite of some patently hand-painted areas, the regular, clear-cut edges give this picture the cold, industrial look of a printed image.*

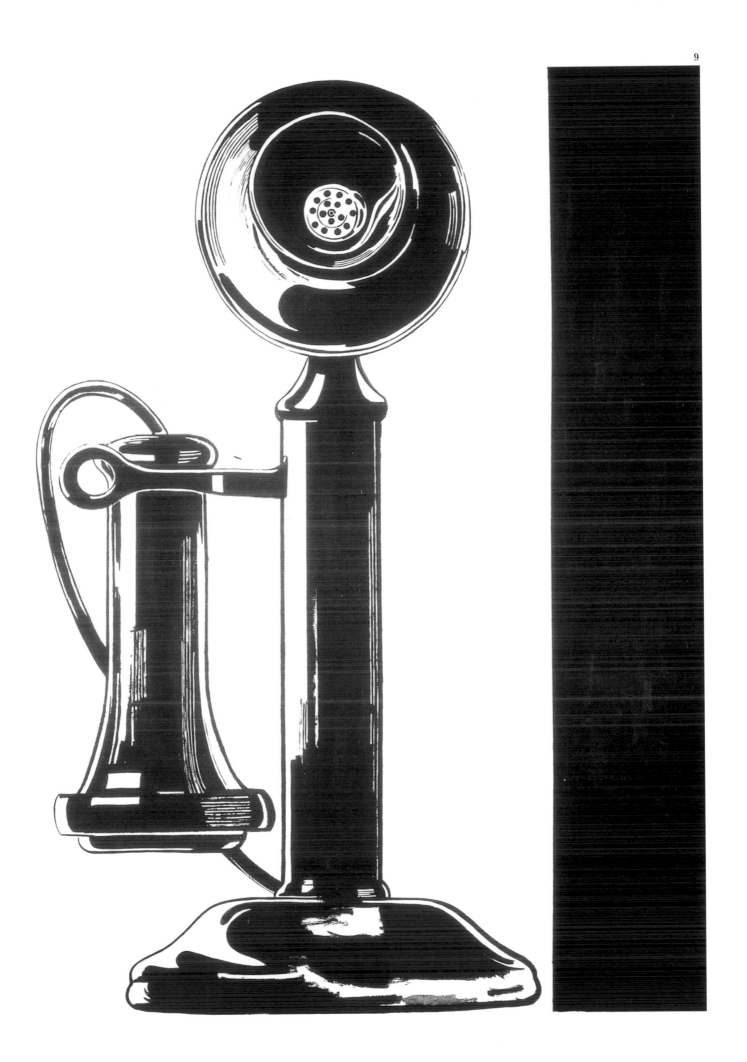

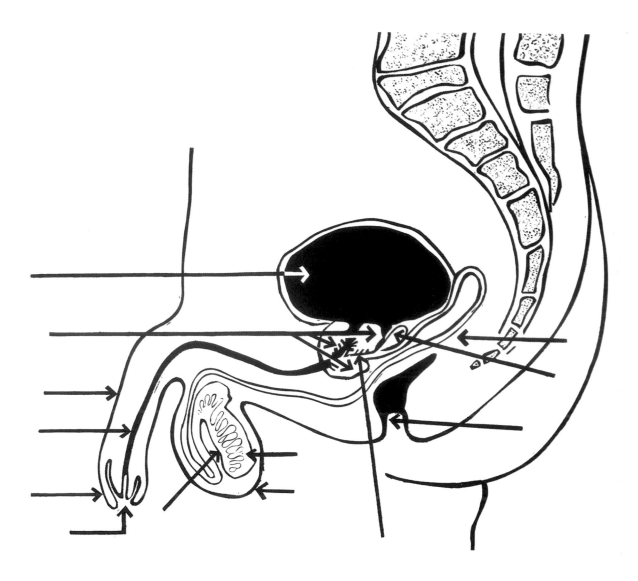

10 Untitled (Hernia), *1960–62. This diagram, an illustration of the male sexual apparatus, seems taken from a textbook or a medical reference book, stripped of its explanatory legend with the corresponding terminology. It is unmistakably reminiscent of certain Surrealist imagery as well as of Marcel Duchamp's ready-mades, even though Warhol's intervention as an artist, by painting it directly on the canvas, exceeded the mere clipping and decontextualization of a pre-existing drawing.*

11 Dance Diagram (Tango), *1962. This image is a black-and-white reproduction of a diagram from a handbook that teaches the steps of ballroom dances. The artist's intervention is limited to a shift in scale, medium, and installation (from its intended horizontal placement on the floor to being displayed vertically on a wall). Here Warhol followed the same course as Lichtenstein, who, the same year, had copied the diagrams from Erle Loran's book* Cézanne's Composition *into his own* Portrait of Madame Cézanne.

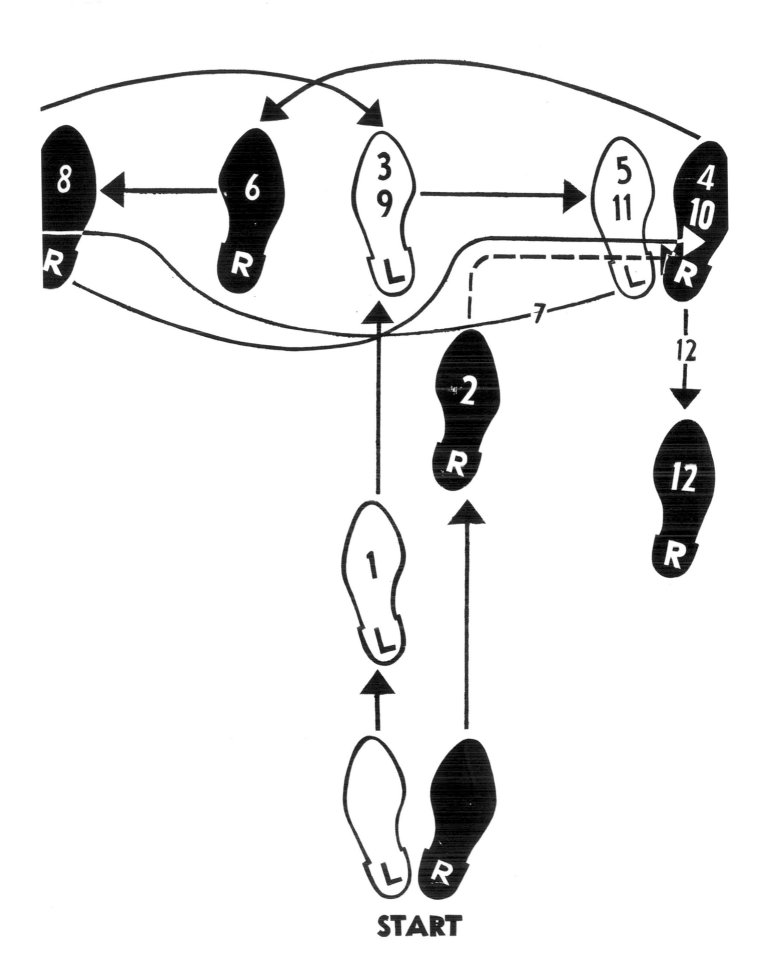

START

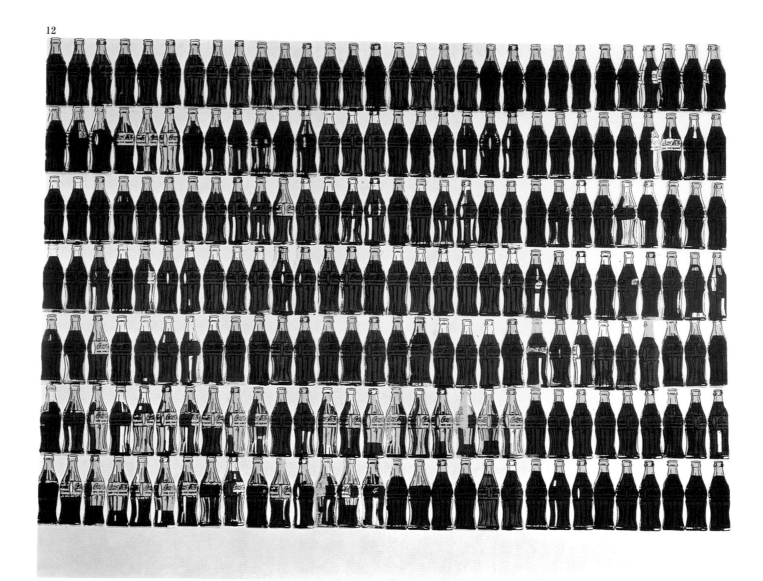

At the Supermarket

In 1966 Warhol decided to fend off accusations launched against screen-printing as too mechanical a process and therefore not applicable to works of art. Warhol had started using this technique in 1962—it is still unresolved whether he or Rauschenberg was the first to make use of this medium—because it expedited his work, but, at the time, he was still not fully aware of all the possibilities that silkscreen printing could afford. Warhol had originally resorted to this method for his sketches; in the end, it resulted in his single most important technical contribution to contemporary painting. Not only does screen-printing enable the immediate appropriation of an image, it is an easy-to-use process that is open to unlimited replication. His earliest silkscreens on canvas are those of the Dollar Bills series, but he also used the screen-printing technique to reproduce boxes of Campbell's Soup (avowedly singled out because it constituted the staple of his daily diet), Heinz ketchup, and Brillo pads—three products that, through Warhol's work, have achieved a genuinely iconic status in contemporary civilization. Warhol once said that "department stores are kind of like museums"; here the supermarket has been transformed by the artist's whim into a kind of museum as well.

12 Coca-Cola Bottles, *1962: This work is composed of the consecutive repetitions of three views of a Coca-Cola bottle reproduced in a strictly linear formation. The viewer is at once aware of color variations, but only a closer examination reveals the differences in the model itself. What seemed to require merely a cursory glance demands instead a detailed observation if the viewer wishes to apprehend the significance of the work in its entirety.*

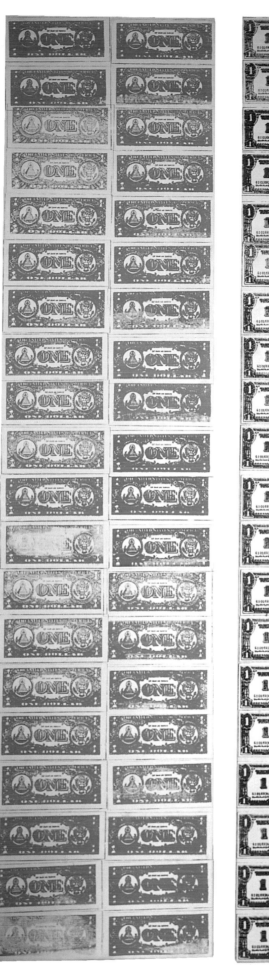

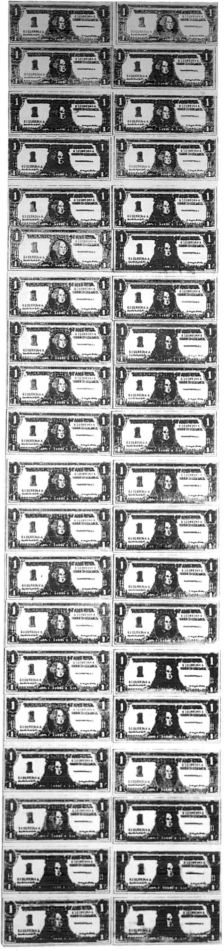

13 Front and Back Dollar Bills, *1962. For this series, Warhol first prepared two silkscreen plates of a one-dollar bill by hand and later printed it on the canvas, albeit not necessarily in orderly fashion. Installations of money hanging on a wall appear to have been one of the artist's most characteristic jokes. The spiritual quest traditionally associated with the artistic enterprise is here replaced by the celebration of monetary remuneration. Left unresolved is the question of whether Warhol's was a cynical posture or a brutal form of honesty with regard to the real nature of art as a commercial transaction.*

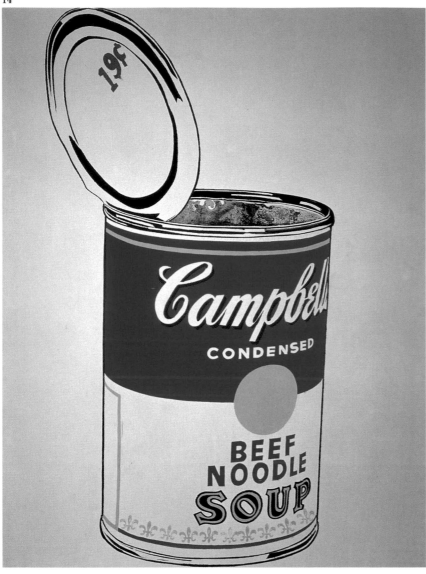

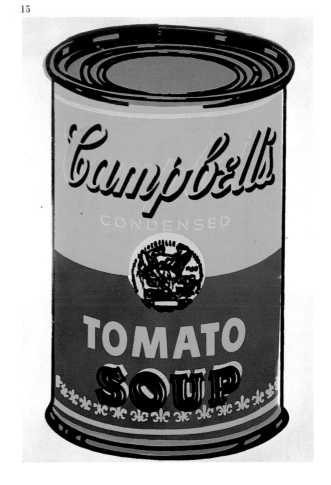

14, 15 Big Campbell's Soup Can, 19 Cents, *1962;* Campbell's Soup Can, *1965.* Warhol *always introduced slight variations to the original makeup of the objects that he copied. In the case of the soup cans, he eliminated the design of the seal impressed in the circle at the center and sometimes emphasized the lettering with an additional border—two procedures the artist employed intentionally, as confirmed by some of his assistants. There are also, however, differences between the motifs themselves, and two soup cans are never identical: their colors change, as does their position; some are open while others are closed, and some still retain the price marking, as if they had just been purchased by the artist.*

16 100 Campbell's Soup Cans, *1962. In 1980 Warhol declared that he wished to be remembered as a soup can, which may very well become the case, since in his work he reiterated time after time precisely that image. One of the* raisons d'être *of this type of work is quite simply the multiplication, the ironic self-plagiarism in a society in which culture and low-cost products apparently go hand in hand.*

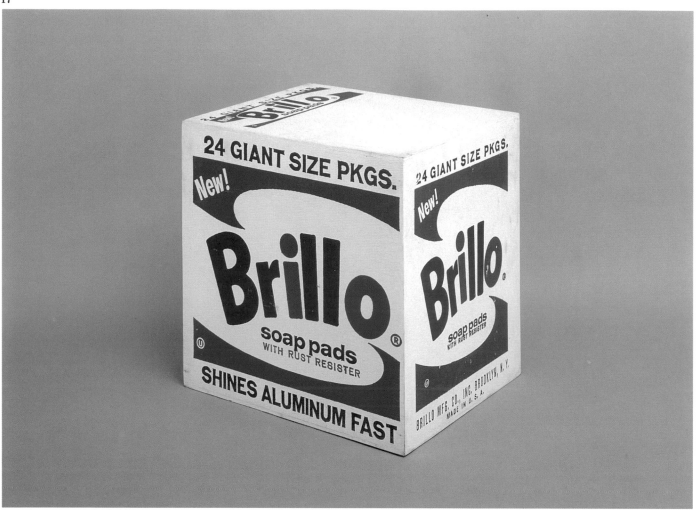

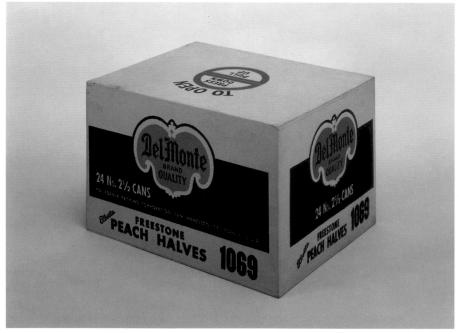

17, 18 Brillo Box (Soap Pads), *1964;* Del Monte Box (Peach Halves), *1964. For his grocery-carton sculptures, Warhol utilized dozens of wooden crates, which he and his assistants first painted the same color as the original cartons, then silkscreened on each face a facsimile of their respective designs. These series tackle the dual issue of three-dimensional art and of ready-mades. In this case, Warhol's inspirational sources included both the work of Marcel Duchamp and Jasper Johns's sculpture* Painted Bronze *(1960).*

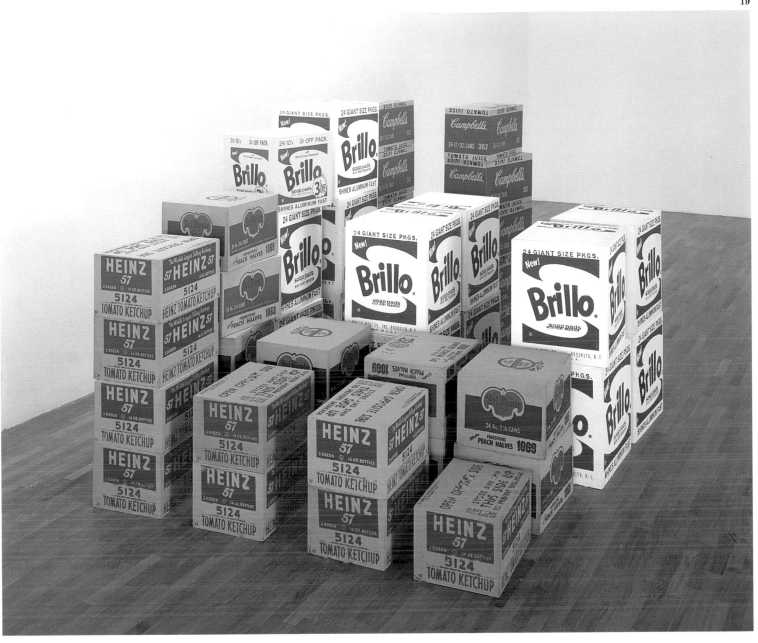

19 *Various Boxes, 1964. The interest of this work lies in its theatrical value, since it depends on its artist's ability to adequately arrange the objects in a fitting space more than on the intrinsic qualities of the objects by themselves. This installation is clearly reminiscent of some typically Minimalist works. During the 1960s, Carl Andre and Robert Morris probed exactly this type of artistic expression, swinging back and forth between two compositional extremes: absolute order and absolute disorder. In the work under examination, Warhol appears to have elected an original and intermediate formula: his boxes—arranged in rows—are sometimes unexpectedly displaced or gently pivoted.*

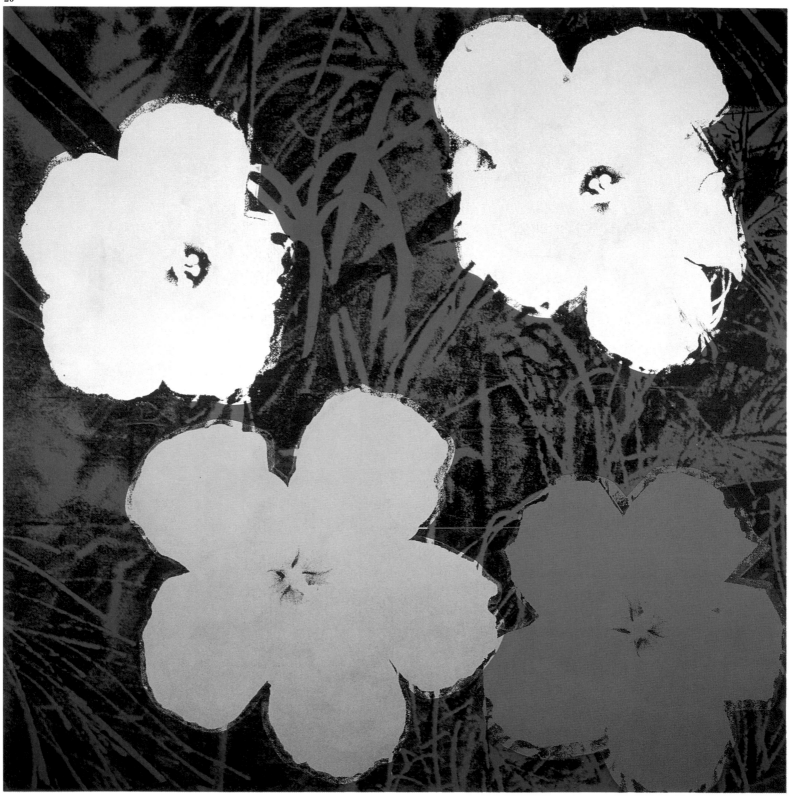

20, 21 Flowers, *1966; Cow, 1966. Thematically, both works are tuned in to the prevalent hippie aesthetics of the times. The first version of the Flowers series dates from 1964; it arose from a photograph published in* Modern Photography *magazine. Originally Warhol's idea was to produce large numbers, in different colors, of the two motifs: the flowers on canvas and the cows on wallpaper. The conservators of the Whitney Museum of American Art refused to consent to the wallpaper's adhesion directly to the museum's wall on the occasion of a retrospective held in 1970. The final effect would have been not unlike that of the sweeping mural paintings of Monet's Water Lilies.*

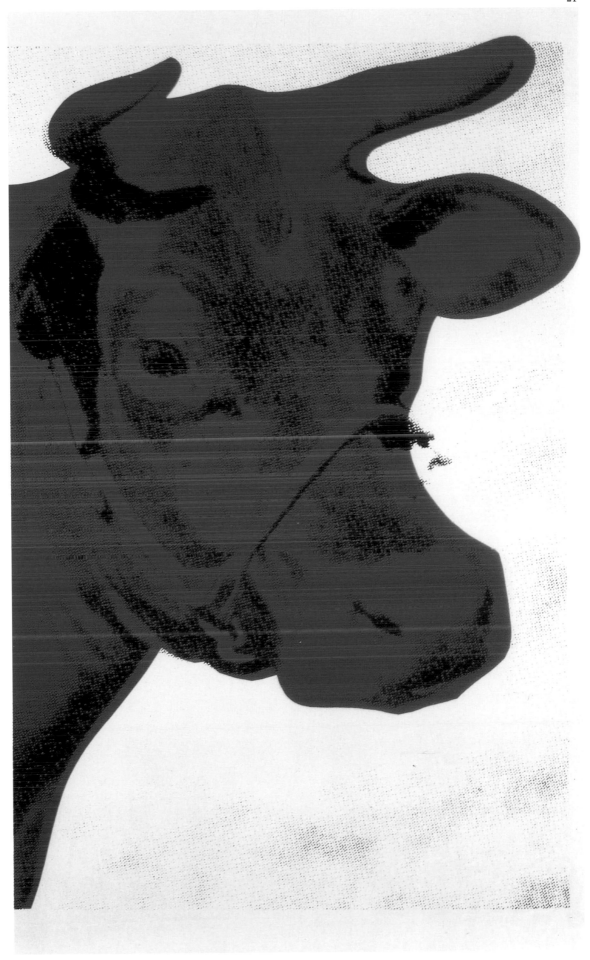

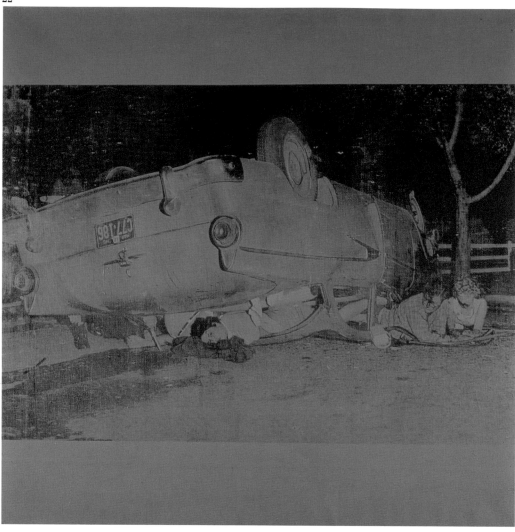

22 Five Deaths on Orange, *1963. A turning point in Warhol's career occurred with the transition from hand-made silkscreens to photographic screen-printing. This mechanical process—which both Warhol and Rauschenberg began using in 1962—consisted of making silkscreen stencils of black-and-white photographs and, in some instances, retouching them with bright colors at a later stage.*

Reports of Death

The other side of American life—the counterpoint to everyday frivolity, that is—are the death-related themes to which Warhol appeared to be strangely but intensely attracted. As a whole, the works in which they appear constitute a sort of documentary chronicle of modern catastrophes, whether acts of God or calamities caused by human intervention. Earthquakes, suicides, plane crashes, automobile accidents, the atomic bomb, and the electric chair are all incorporated into the artist's iconographic repertoire. For the most part, the themes and distinctive layout of these images were directly derived from newspaper articles, whose format was the most effective for this type of motif: in some instances, Warhol even chose to reproduce—with oil paints on canvas—entire newspaper pages, and those paintings ended up looking like ready-mades. In most of them, the artist obsessively repeated the same strangely colored and juxtaposed images, with the result that the viewer is somehow urged to scrutinize and ponder the same tragedy over and over. Warhol's attitude was typical of his age, an era in which the public had become numbly accustomed to the most atrocious horrors. As a chronicler of his time, the artist presents the images unedited: he provides no commentary, the mere selection of a particular image representing his own critical contribution.

23 129 Die in Jet (Plane Crash), *1962. While painted entirely by hand, this work is almost an exact reproduction of the first page of a daily newspaper chronicling the dramatic crash of a flight that had originated in the United States while preparing to land at a Paris airport. The disaster had more than a personal resonance; it also marked a cultural and artistic loss, since many of the victims were sponsors of the Atlanta High Museum of Art.*

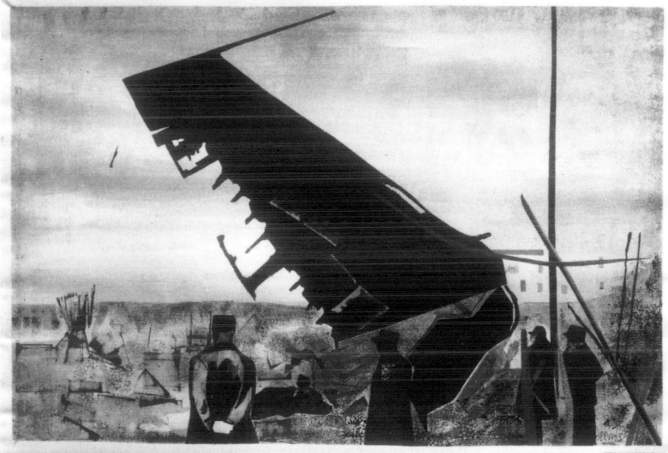

FINAL ★★ 5¢ New York Mirror

WEATHER: Fair with little change in temperature.

Vol. 37, No 296

MONDAY, JUNE 4, 1962

C

129 DIE

(UPI RADIOTELE photo)

IN JET!

24 Car Crash, *1963. For the most part, Warhol's death-related images are based on press agency photographic material. In some instances, as in the work at hand, the image is tirelessly repeated, since the artist—as he stated in a 1980 interview— believed in quantity rather than quality. The wreckage's heap of mangled scrap keeps haunting the viewer's imagination time after time.*

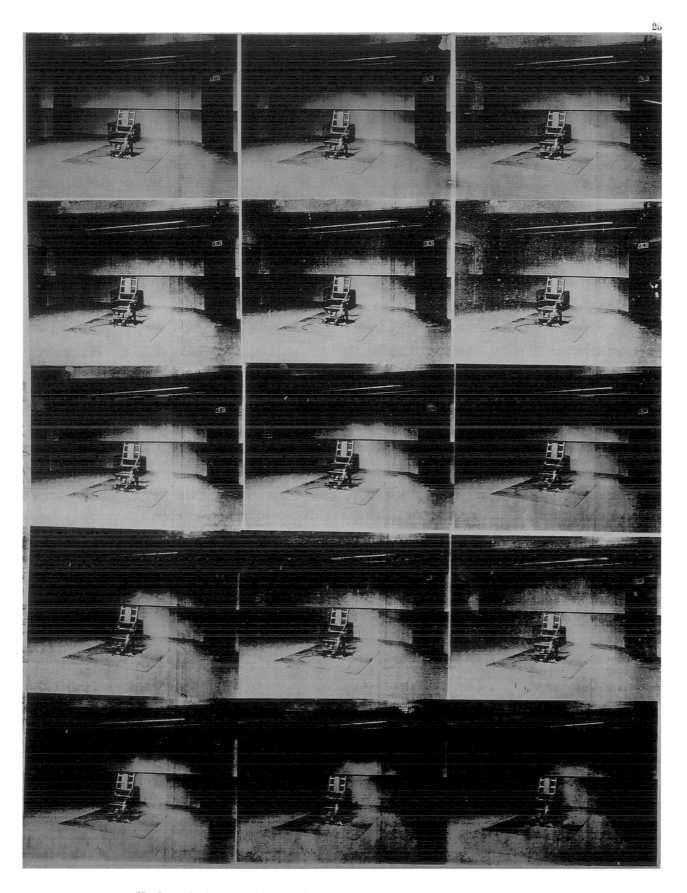

25 Lavender Disaster, *1963. The electric chair as an execution device is—like everything else in Warhol's work—a typically American artifact. The vacant and solitary space is filled only by the chair, which, no longer an object of everyday life, has been transformed into a lethal seat of torture. The lighting tinges the stark hall with a sophisticated mauve tone—the title alludes to Pollock's famous* Lavender Mist—*that assuages the anxiety of the viewers, whom a sign on the right-hand side instructs to remain silent.*

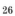

26

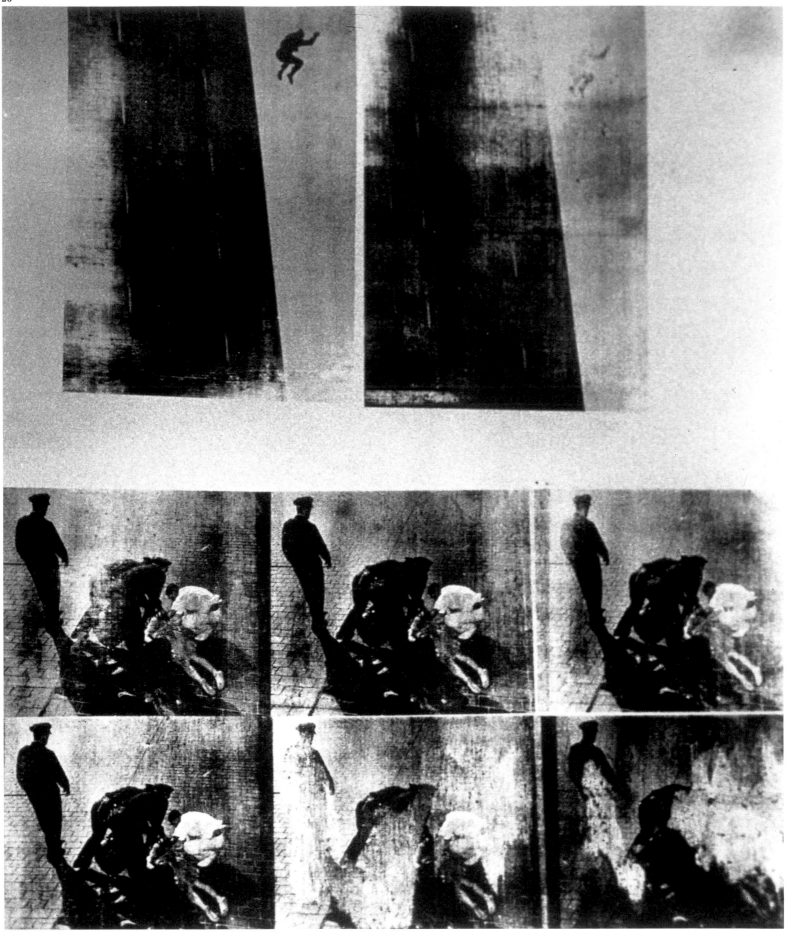

26 Suicide, *1963. This spectacular suicide—a jump from the Empire State Building—is one of the few examples of Warhol's work on death in which the actual victim is represented. The subject remains unidentified, but thanks to a singular death, s/he belatedly achieved fame—a macabre instance illustrating one of Warhol's better-known statements: "In the future, everybody will be world famous for fifteen minutes."*

27 Tunafish Disaster, *1963. The link between mass consumption and death is apparent in the case of these two women who were poisoned by the ingestion of tainted tuna. The black-and-white composition is nearly identical to the original photograph: it even includes the same exact text accompanying the news of the two deaths.*

UPI

Seized shipment: Did a leak kill . . .

. . . Mrs. McCarthy and Mrs. Brown?

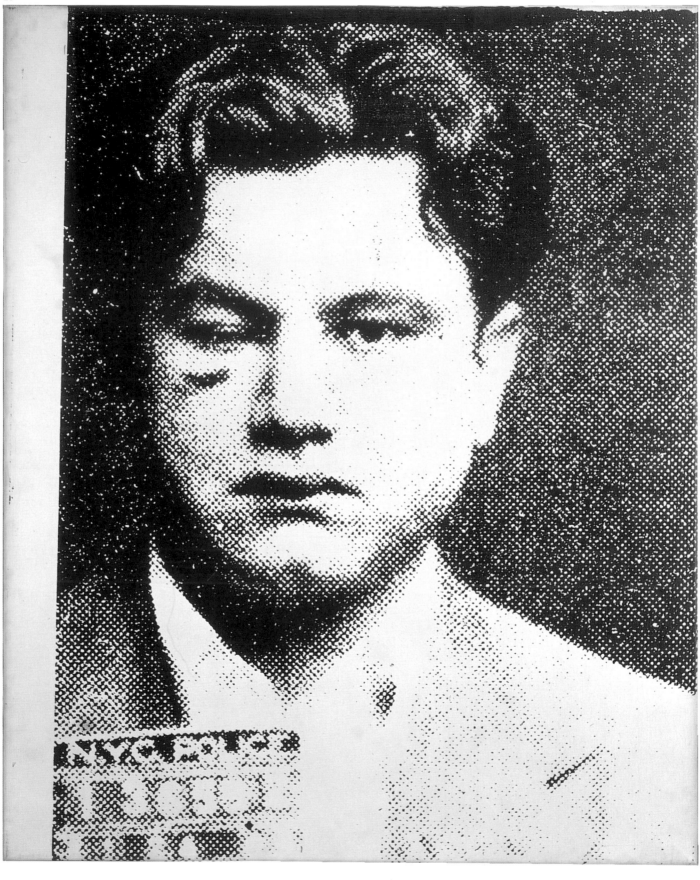

28, 29 Most Wanted Men, No. 2 John Victor G., *1964;* Most Wanted Men, No. 2 John Victor G., *1964. Don't criminals have a right to be famous? Warhol designed a large mural for the New York State pavilion at the 1964 World's Fair with the pictures of thirteen alleged criminals. The original small photographs were obtained from the archive of the Federal Bureau of Investigation. Warhol converted them into large silkscreens, which accounts for the huge dots and graininess of the images. The installation raised widespread indignation, which in turn led to the withdrawal of the works and their obliteration with a coat of silver paint.*

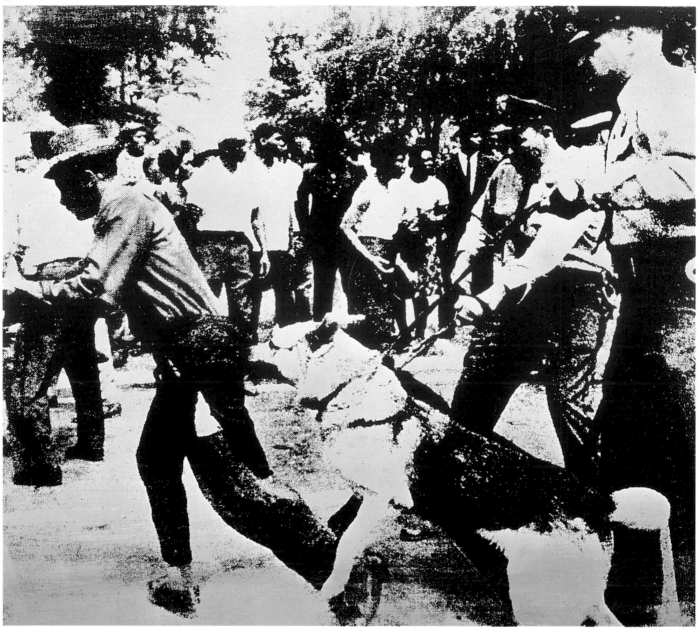

30 Small Race Riot, *1964. In spite of Warhol's seeming political neutrality, several of his works drew inspiration from the problems associated with the racial question in the United States, namely the uprisings that had been taking place in Birmingham during that period. These images are genuine denunciations of intolerance, violence, and brutality. The artist's censure is expressed solely but powerfully by the striking and bare evidence of the images, without the further addition of any other form of commentary.*

31 Atomic Bomb, *1965. Warhol's intention, with this red-tinted apocalyptic image, is to force the viewer to ponder the subject of death, which had become his own personal obsession. The artist tackles his theme with the same desensitized moral and emotional disposition as did Manet in the latter's versions of* The Execution of Maximilian*. Whether one likes them or not, these paintings by Warhol speak volumes on the modern condition of the human race.*

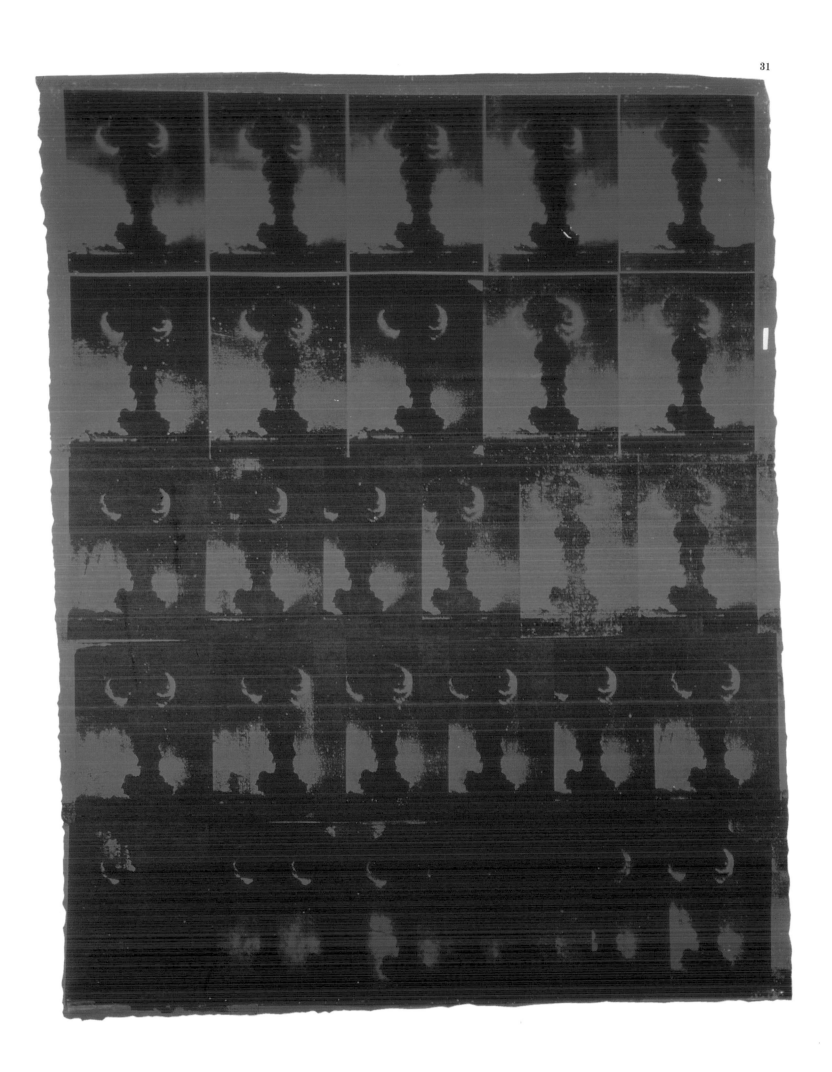

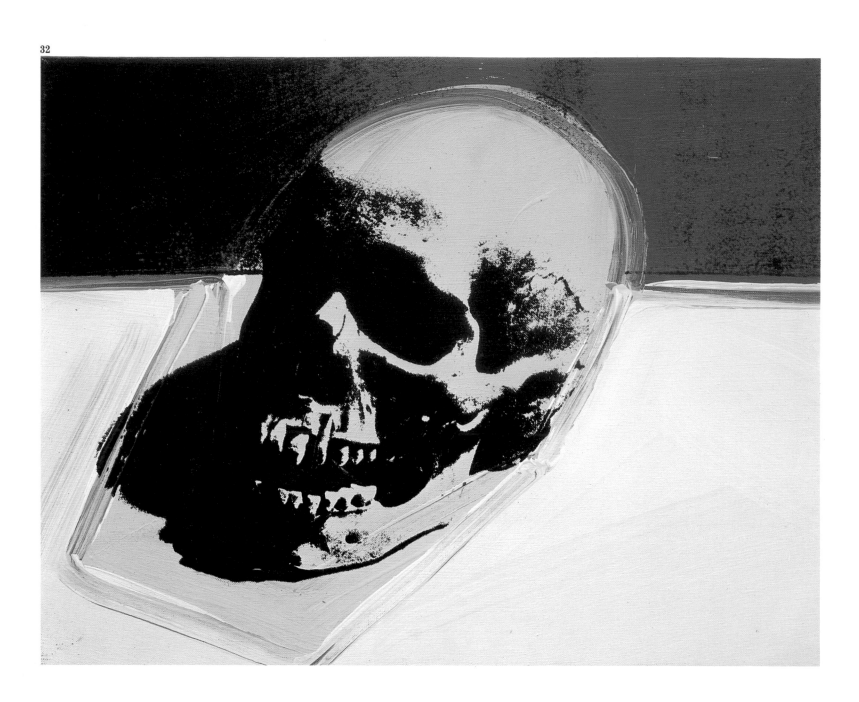

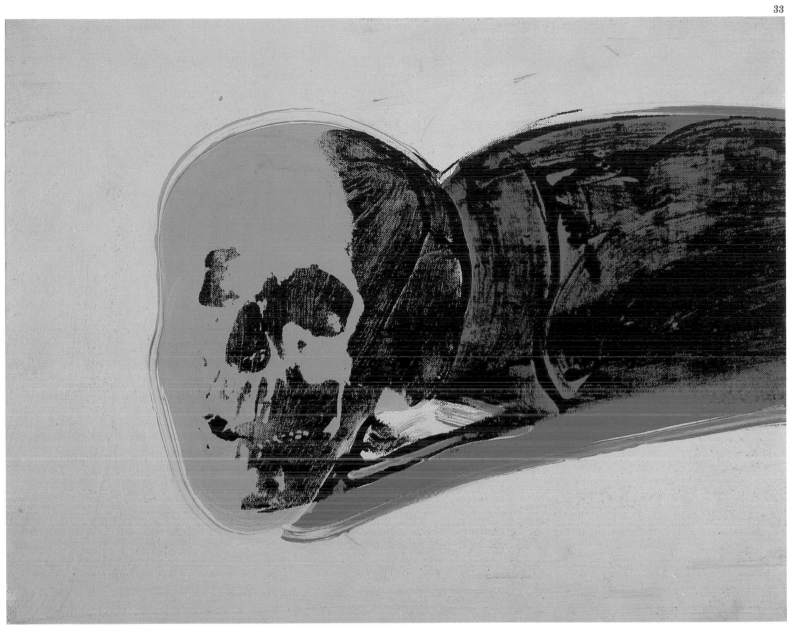

32, 33 Skull, *1976–77*; Skull, *1976–77*. As far as the use of color is concerned, these are among Warhol's boldest compositions. The skull—a macabre sublimation of the portrait genre—marks the culmination of the artist's series of works on death, while its continual reiteration may be seen as a naïve form of exorcism following the attempt on his life in 1968.

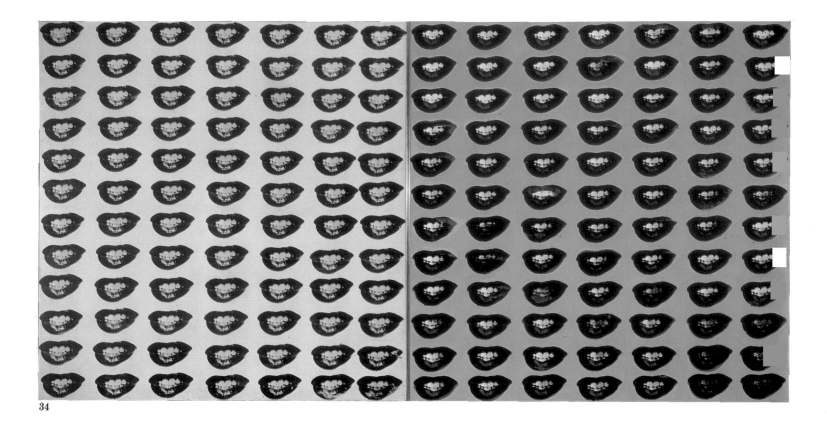

34

Warhol as Court Painter

Andy Warhol's portraits constitute a genuine gallery of the most influential and famous figures of his age. Politicians, movie stars, and art dealers are among the many names in this long list. None of them was ever chosen by accident: they are all emblems of beauty, glamour, or power; and if that was not the case, Warhol himself made sure they would be transformed into genuine icons through his own work. Even though, for the most part, these celebrities already belonged to the imagery of Pop culture, Warhol's treatment endowed them with a very distinctive quality. He normally first took a snapshot of his subject, then carefully altered it by dislocating the contours and adding new polishes and colors. In many instances, these works are double or multiple portraits, emphasizing the overwhelming presence of their models' already larger-than-life bodies. The ease with which these portraits could be replicated gave a boost to the artist's success and profits, and Warhol never concealed the fact that the genre had become for him an easy moneymaking tool.

34 Marilyn Monroe's Lips, *1962. Marilyn Monroe's lips are unquestionably the most erotic symbol of her widely familiar features. Thousands of moviegoers have been affected by the desire to kiss those lips. Reduced to a mere anatomical fragment, Marilyn Monroe is here converted into a sort of kissing machine which, ironically, entails the very dismissal of the romantic possibility of a kiss.*

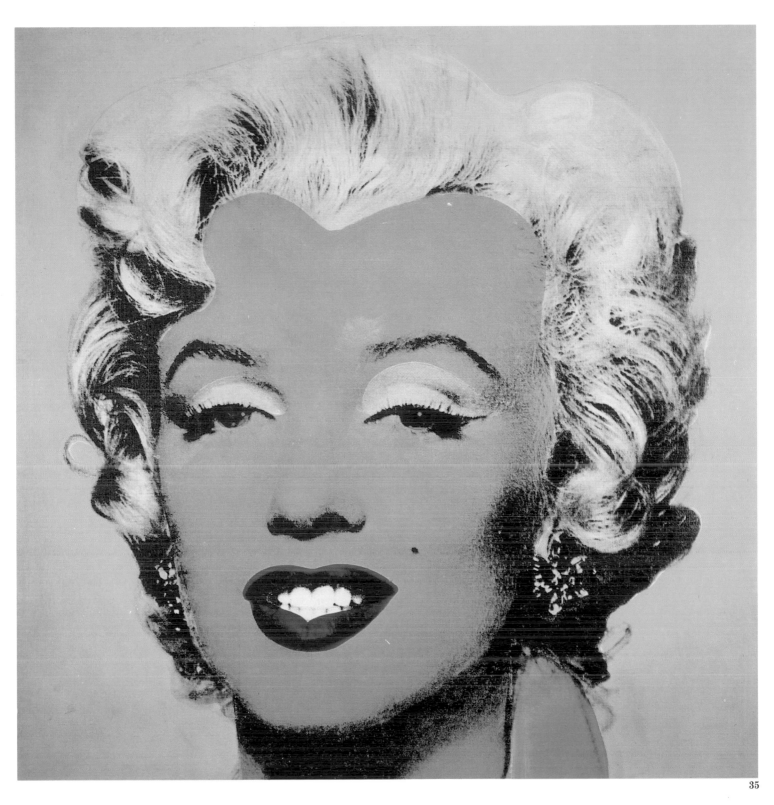

35 Marilyn, *1964. The use of Marilyn Monroe as an artistic theme made its first appearance in 1954 in a painting by Willem de Kooning. After the actress's suicide, in August 1962, Warhol focused some of his most famous series on her image, depicting her as a goddess of sensuality and eroticism. The portrait emphasizes precisely those features that were most emblematic of her status as a sex symbol: her red, sensuous lips and her bleached blond mane.*

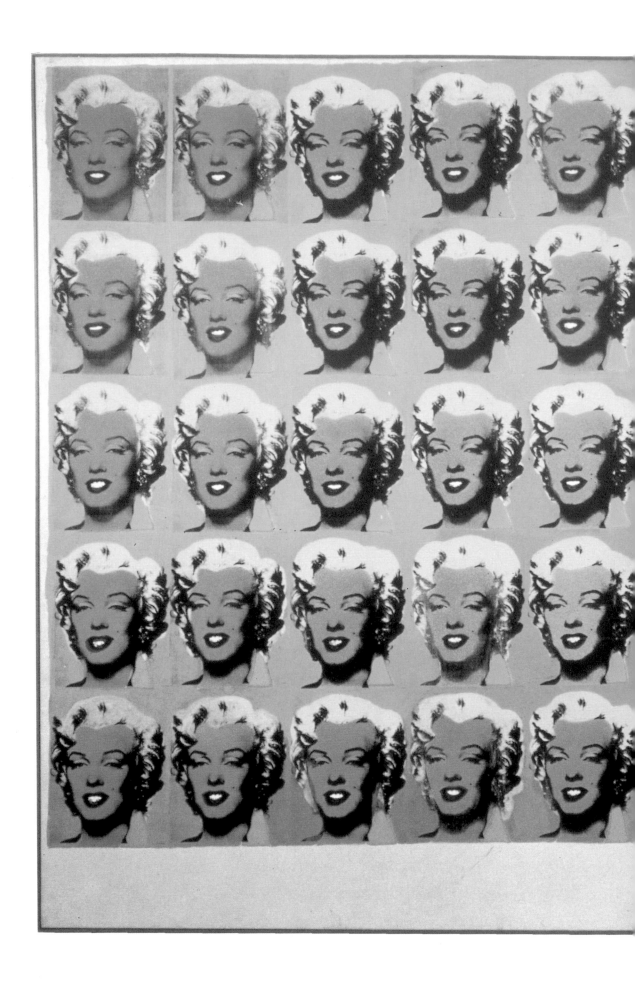

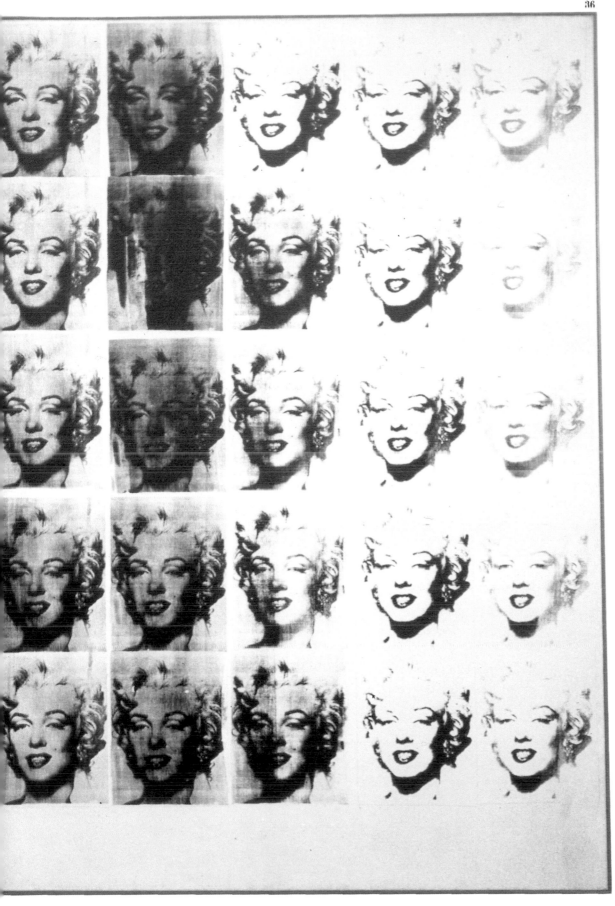

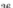

36 Marilyn Diptych, *1962. A promotional image for the 1953 film* Niagara *was at the origin of Warhol's famous portrait of Marilyn Monroe. Through its endless repetition the artist succeeded in transforming the actress into a sort of holy image—as in his* Gold Marilyn Monroe—*an effect enhanced also by the dual composition of this work, in the typical manner of devotional and sacred diptychs.*

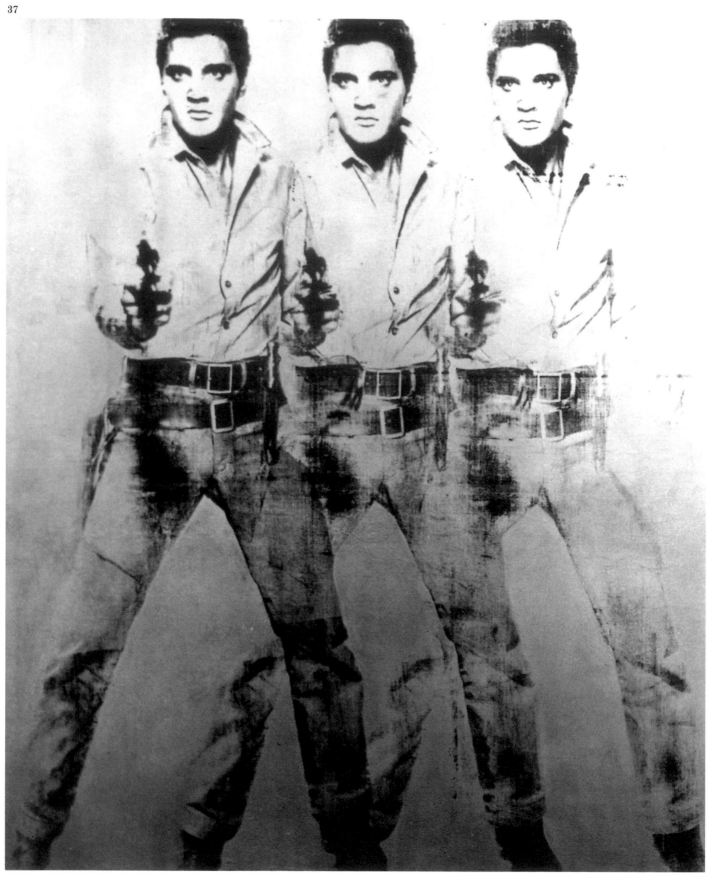

37 Triple Elvis, *1962. As if in a series of superimposed photographs, this image seems to be moving with suggestive rhythm over a silver background. Warhol obtained this effect with the same type of spray paint used for the bodywork of automobiles. The story of Elvis Presley—a humble youth who, thanks to his music, achieved immense fame and elicited hysterical adoration on the part of young people the world over—is somewhat reminiscent of the artist's own. The other side of the coin, of course, was Elvis's continual bouts of depression and his problems with drugs and alcohol, which led him to a lifelong flirtation with death.*

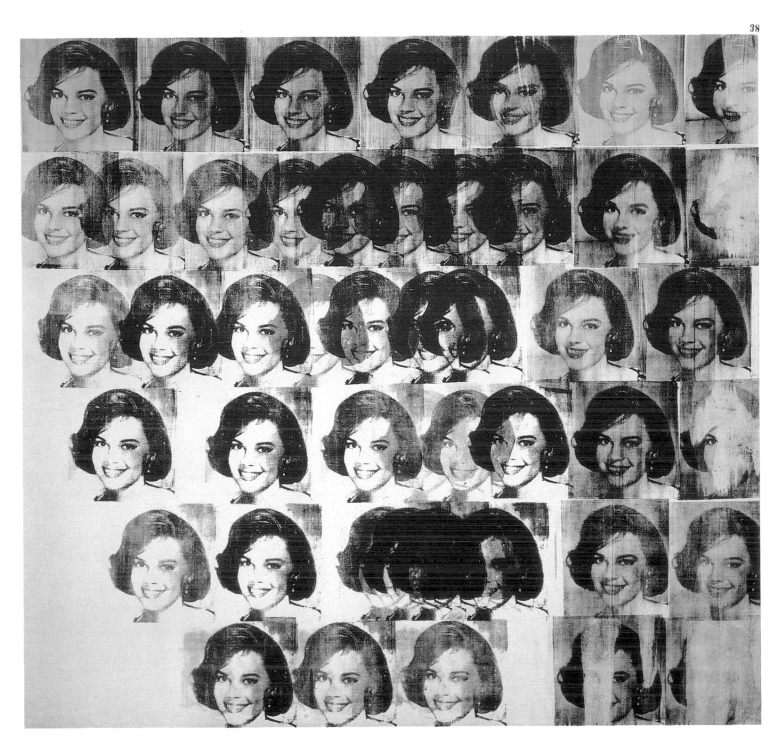

38 Natalie, *1962. According to the artist, this tireless repetition of the gentle features of Natalie Wood—who had recently starred opposite Warren Beatty in the blockbuster movie* Splendor in the Grass—*was directly justified by the demands of the viewing public. Warhol asserted that since moviegoers appear to be interested only in the image of the star, he chose to repeat that very image indefinitely. That is the same reason why, in his own films, Warhol often showed the same actor performing exactly the same action for hours on end, whether eating, sleeping, or smoking.*

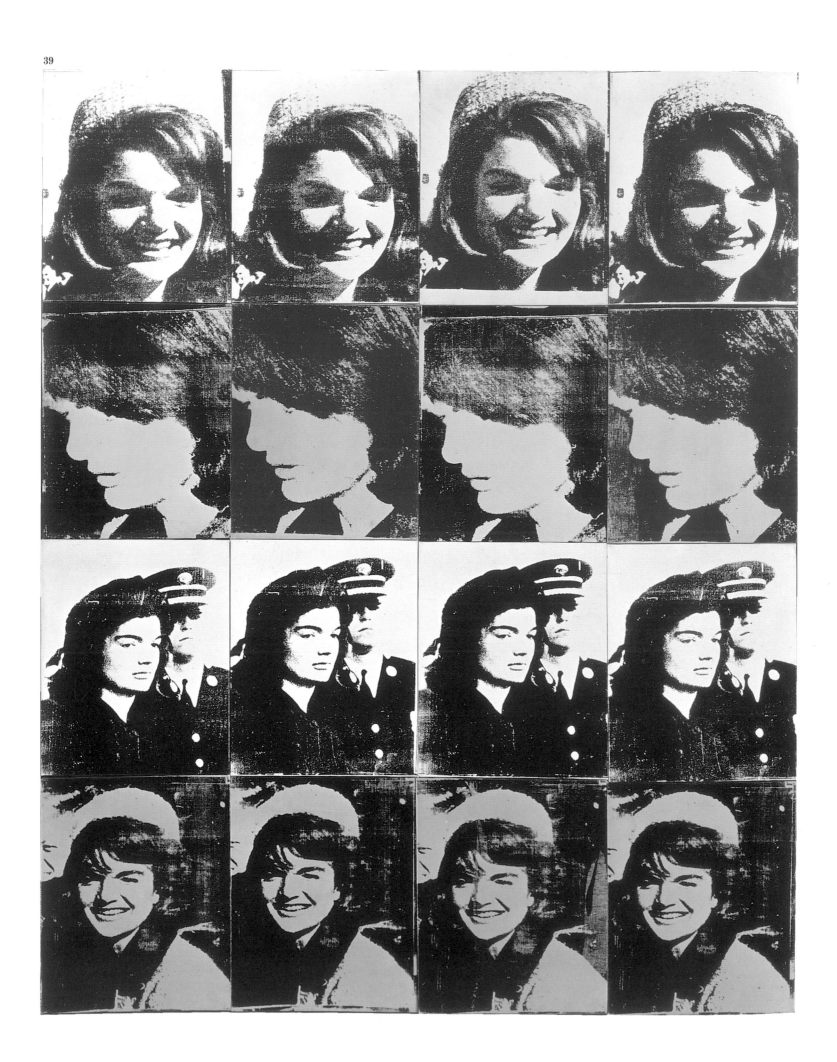

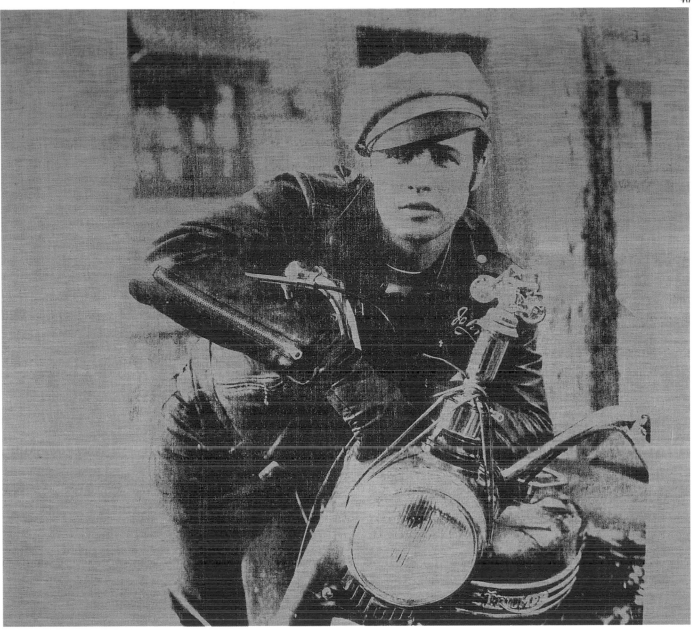

39 Sixteen Jackies, *1964. Like most Americans, Warhol was profoundly moved by the assassination of the youthful President John F. Kennedy, on November 22, 1963. One of the consequences of this tragedy was Jacqueline Kennedy's transformation into the quintessential widow. Her image, reproduced over and over in periodicals and on television, traveled throughout the world. Warhol's series, in which Jackie is shown both smiling and weeping, is a powerful intimation of how unexpectedly and easily one's lot can change.*

40 Marlon Brando, *1966. Brando embodied the prototype of the manly man. The image selected by Warhol consciously or unconsciously underscores the strong sexual component shared by many of the celebrities that he portrayed. The use of a silkscreen-processed photograph thoroughly eliminates any trace of the artist's intervention.*

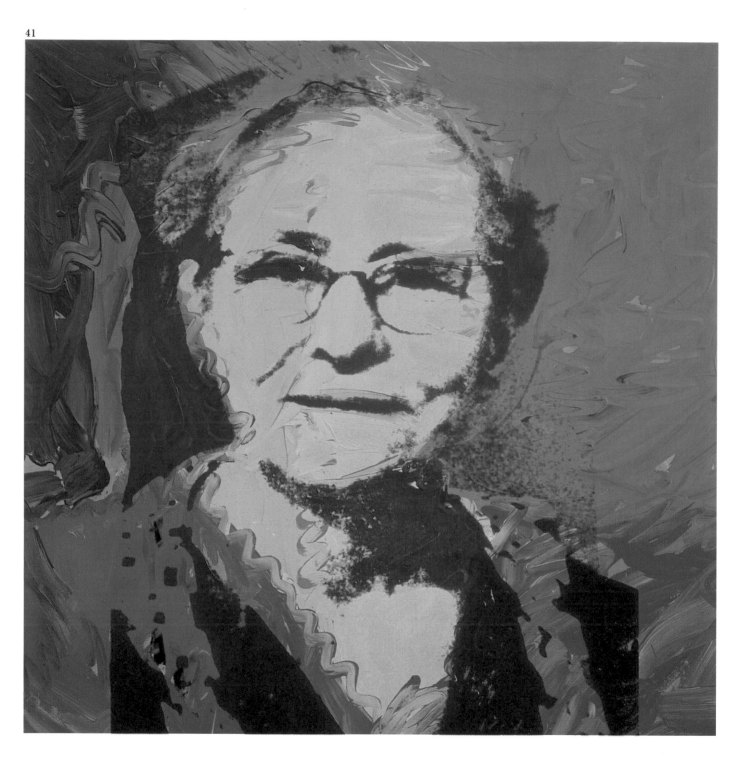

41 Julia Warhola, *1974. Warhol painted this portrait of his mother—undoubtedly the most influential woman in his life—two years after she died in Pittsburgh, at age eighty, after living with her son in New York for a number of years. Unlike most of Warhol's contemporary portraits, in this one the sitter's likeness has been subjected to hardly any transformation. The artist's intervention was limited to manually retouching the background and the dress with very swift brush strokes, which may explain why this image looks more like a genuinely painterly portrait than like a parody.*

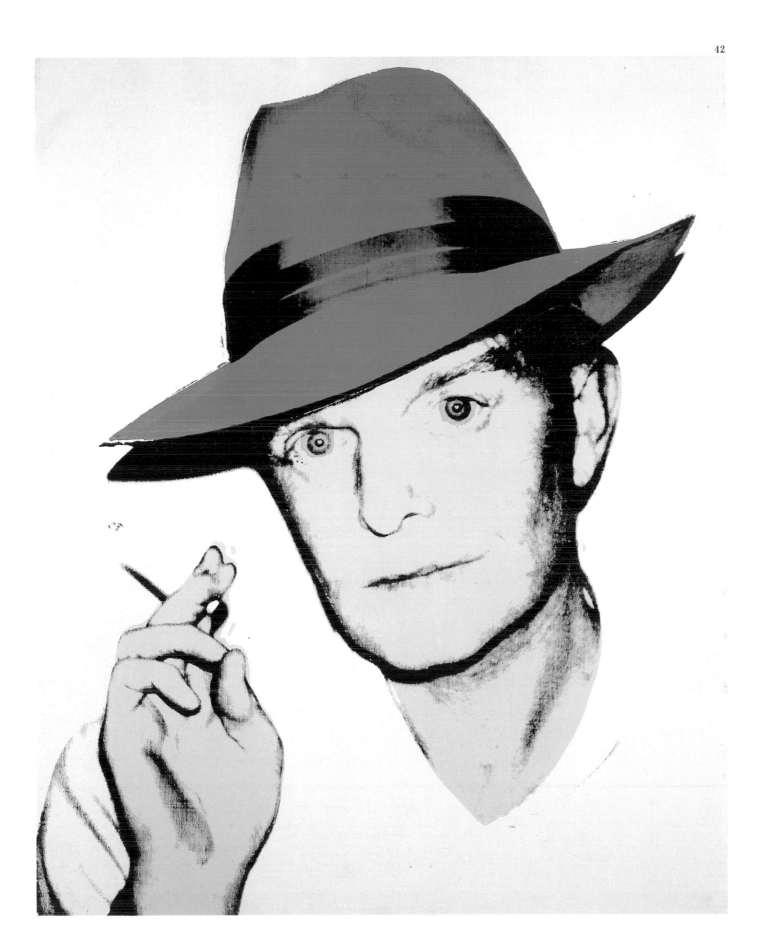

42 Truman Capote, *1979. As a young man Warhol had felt a profound admiration for the writer Truman Capote, whose autographs he collected and to whom he once addressed a letter that was left unanswered. In this portrait, Capote is depicted in his element: a public figure with his face brightly lit by the photographers' flashes. As in all of his portraits of celebrities, Warhol underscores some of the model's most prominent features, in this instance his eyes and his hat.*

43, 44 Ladies and Gentlemen, *1975;* Ladies and Gentlemen, *1975. The artist's manipulation of these images is such that the models' features retain only a mere echo of their likenesses as seen in the original photographs. The resulting portraits possess a certain melancholic quality and are blurred by the successive accumulation of paint. Both portraits belong to a series devoted to African-American transvestites that was shown in its entirety only in Europe.*

Archetypal Forms

Around the 1970s—following a period devoted to a wide variety of artistic enterprises—Warhol resumed his painterly practice with renewed enthusiasm. New themes began to emerge in his work as he started to experiment with an array of new techniques and mediums. In 1972, he undertook a series of silkscreens titled Sunset, a nearly abstract image processed through an infinite number of chromatic variations. His renewed interest in painting manifested itself above all in his portraits of Mao Ze-Dong. By emphasizing the most interesting features of the countenance of the Chinese Communist leader, Warhol's brushwork minimized the most mechanical aspects of those works while promoting the increasingly painterly quality of his artistic production. Warhol's evolution as a painter took him from the sober and bare austerity of the 1960s—sparing in its colors and harsh in its reliefs—to the most intricate style, evinced by such traits as the fluid brush strokes and the imprecise outlines of these portraits. At the same time, the artist's production experienced a significant iconographic shift: movie stars began to be replaced by the stars of museums as Warhol decided to create his own versions of famous paintings. On the other hand, the archetypal forms recurrent in his works from the 1980s—the camouflage and Rorschach test series, that is—verge on pure abstraction, and therefore look back to the farthest origins of his career.

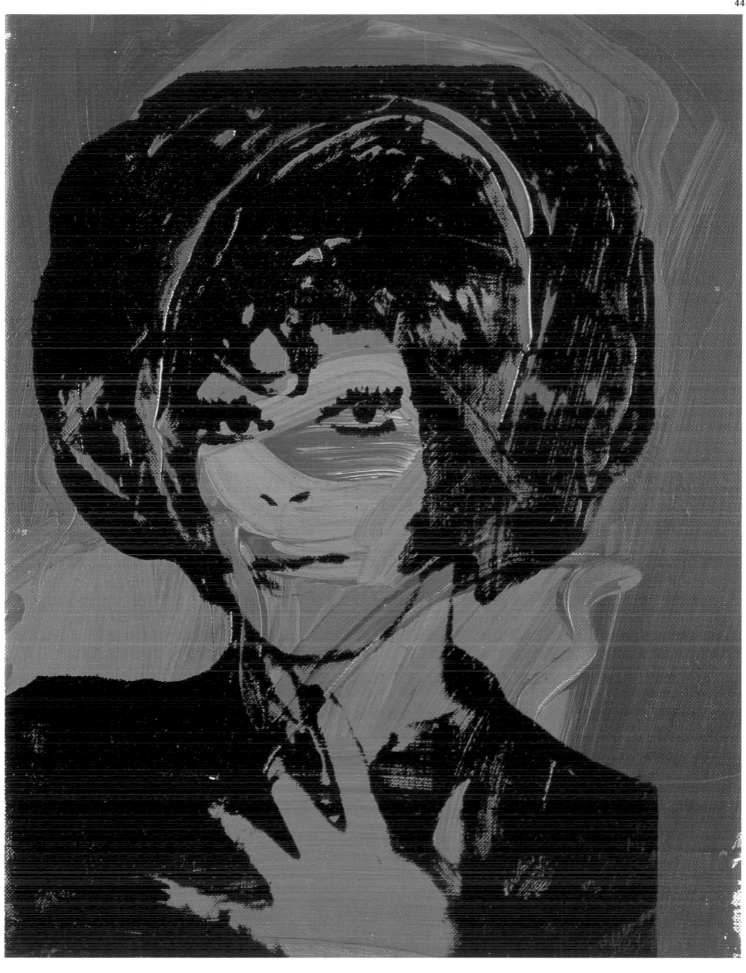

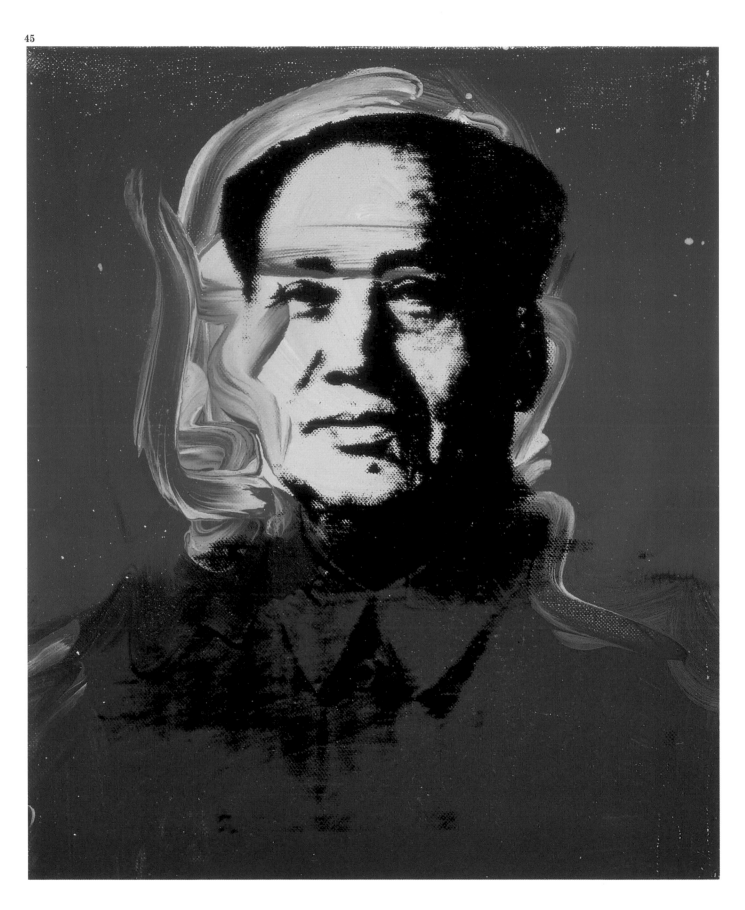

45, 46 Mao, *1973*; Mao, *1973. As a consequence of the student rebellion movement of 1968, Mao became an idol of the younger generations in the West and, paradoxically so, was transformed into a fashionable icon of capitalist society. Then, in 1972, President Nixon made an unprecedented official trip to China. Soon enough, the Chinese Communist leader joined the movie stars among the cohort of models portrayed by Warhol, and, like theirs, his likeness was replicated inexpensively only to be sold later like any other commodity. Mao's presence among those more glamorous celebrities does not in any way indicate a form of political commitment on the part of the artist.*

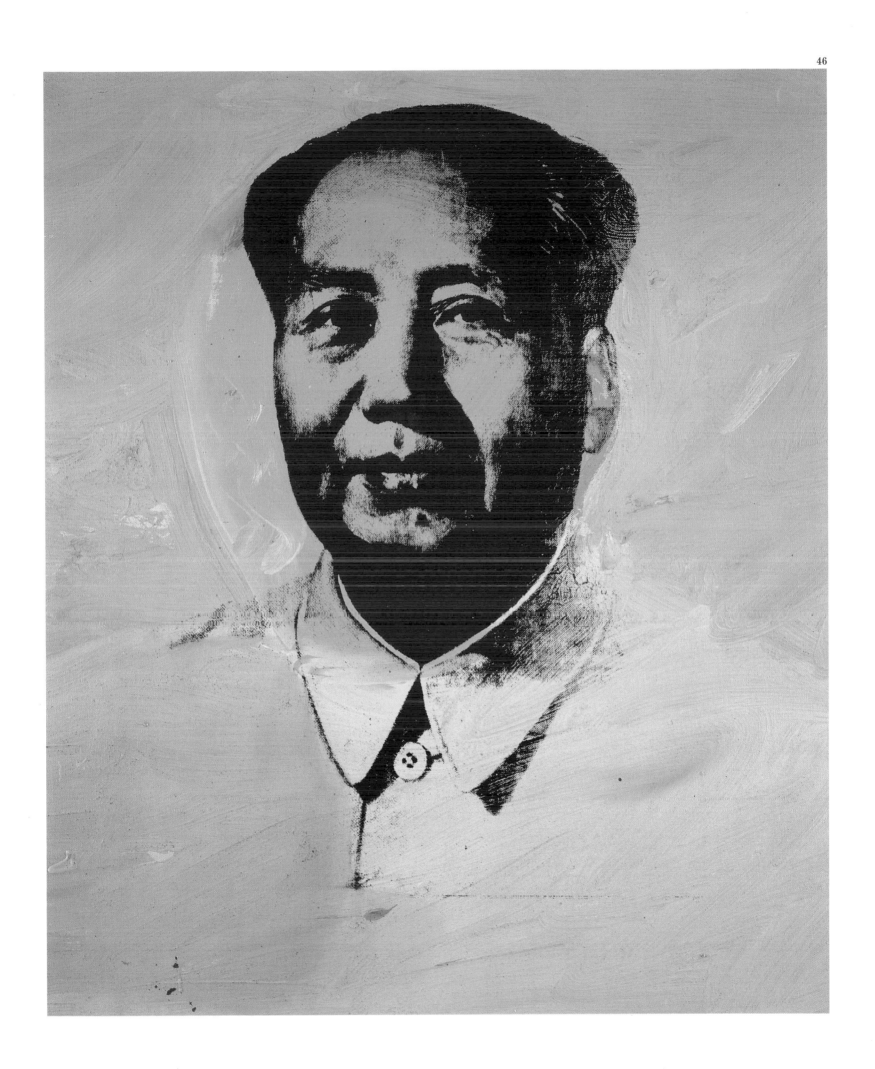

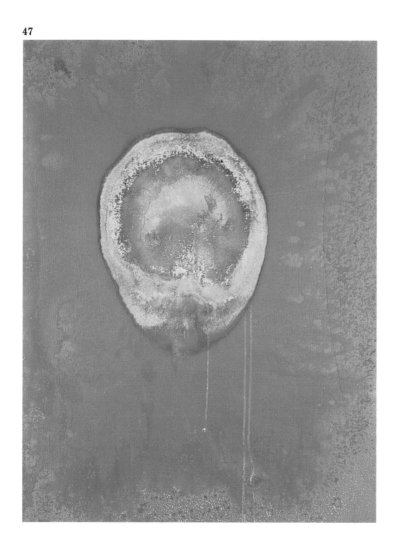

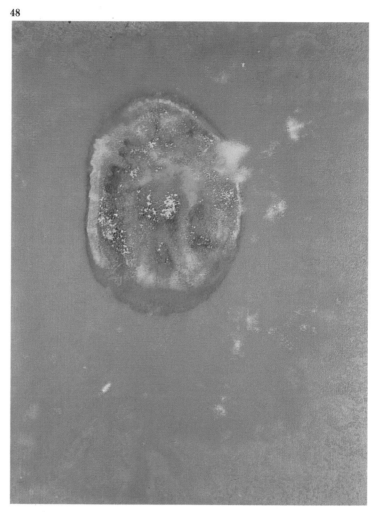

47, 48 Oxidation Painting, *1978;* Oxidation Painting, *1970. The technique with which these paintings were executed involved priming the canvas with a blend of synthetic polymer and metal dust and urinating over it while the priming coat was still fresh: the paint surface turned green in different shapes depending on where it had been attacked by the bodily fluid. The process is reminiscent of Jackson Pollock's drippings: a sublimated emulation, that is, of those works in which that artist let the paint trickle over the canvas. In addition to urine, Warhol used for paintings in this series other unconventional materials, such as melted chocolate, strawberry jam, and semen.*

49 Joseph Beuys, *1980. The glittering effect of the powdered crystal over the model's hat becomes a sort of sacred halo surrounding the head of the German artist who, in this portrait by Warhol, is seemingly transformed into a holy image. Perhaps surprisingly, Warhol had indeed retained a Catholic devoutness from his childhood, and used to pay a daily visit to the church of St. Vincent Ferrer.*

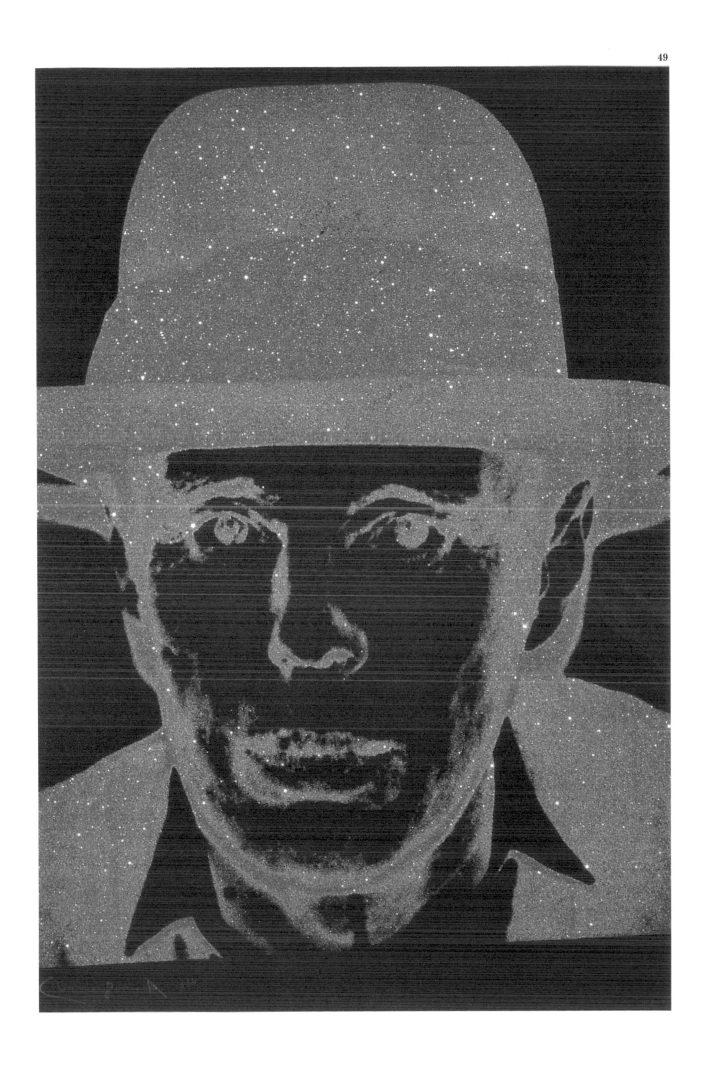

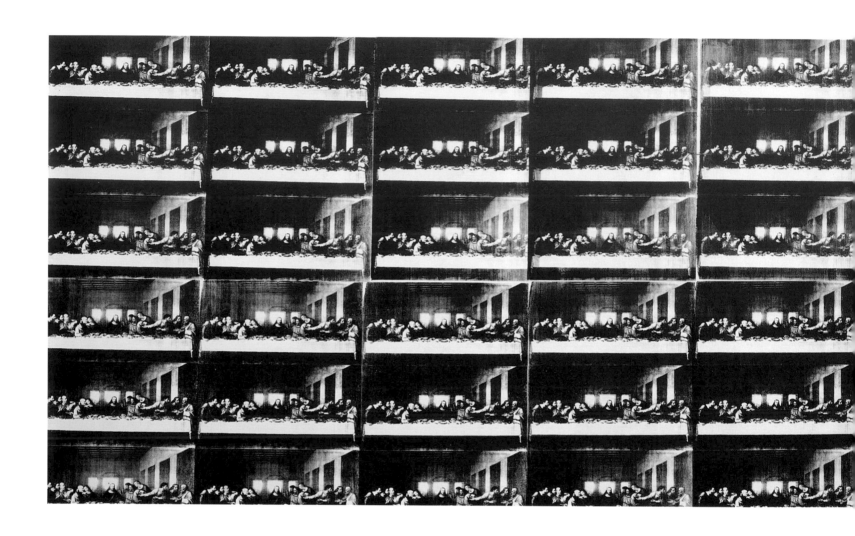

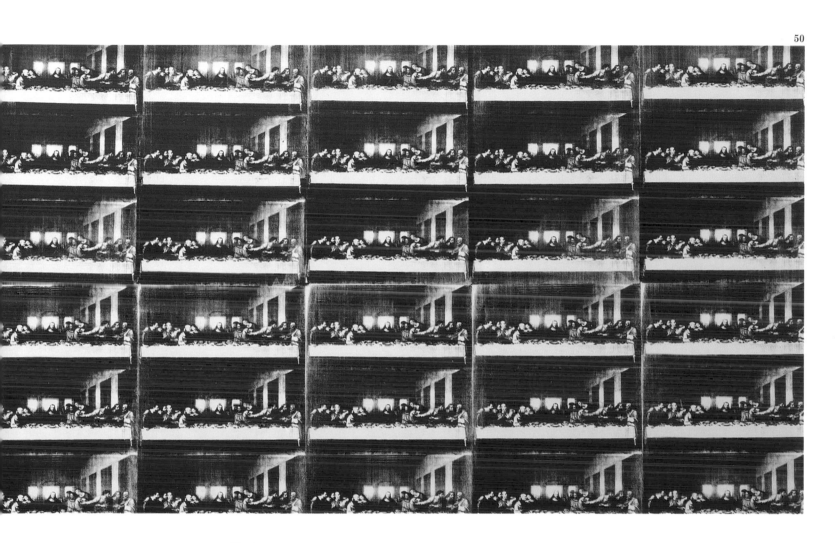

50 Sixty Last Suppers, *1986. During his last years, Warhol undertook to produce his personal interpretation of some of the most emblematic religious works of European painting, such as Leonardo da Vinci's* Last Supper *and* Annunciation, *or Raphael's* Sistine Madonna. *Sometimes these old masterpieces are quoted in their entirety while at other times they are only partially reproduced. In some instances—such as the one under consideration—the original composition is subjected to the same process of serial replication as Warhol's portraits and advertising images. The large format of some of these works is an allusion to the mural paintings and altarpieces found in religious edifices.*

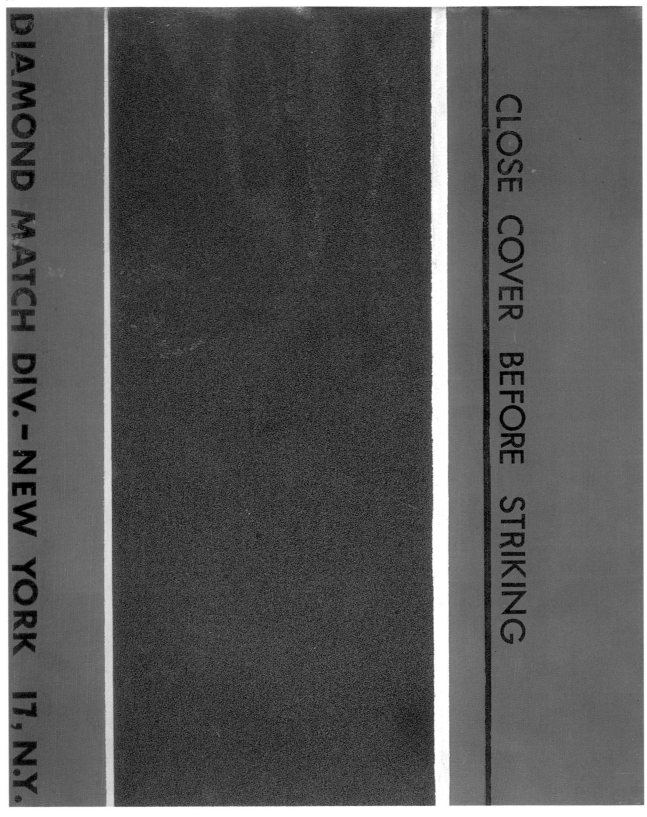

51 Close Cover Before Striking, *1962. This straightforward reproduction of the bottom part of a matchbox is a parody of the paintings by Barnett Newman, whose style was based on the use of empty fields of saturated color bounded by asymmetrically arranged narrow bands. Warhol undermines the impact that such an immense chromatic continuum has on the viewer by inserting a sign that warns not to light matches before closing the cover. The stripe of sandpaper mimics the rough texture of the scraper against which matches are struck in order to light them.*

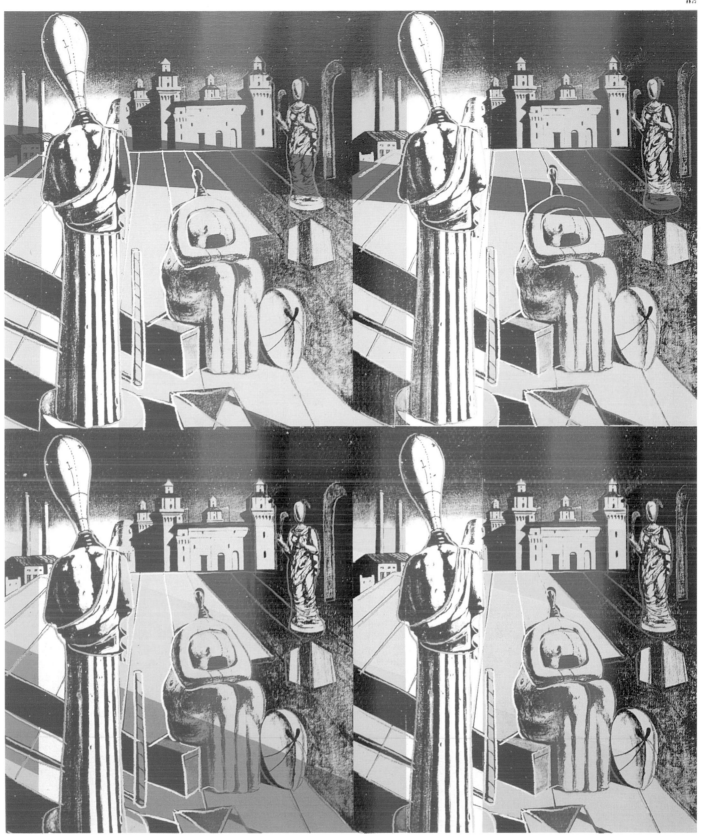

52 The Disquieting Muses (After De Chirico), *1982. The early 1980s saw the rise of a passionate revisionist interest in De Chirico's late production. The Italian artist had for the longest time been accused of having "forged" his own works by dating to an earlier period paintings that he had actually executed at some later time. Warhol, who had been charged with plagiarism throughout his entire career, once more challenged artistic conventions when he produced replicas of his own copies of the works by the Italian master.*

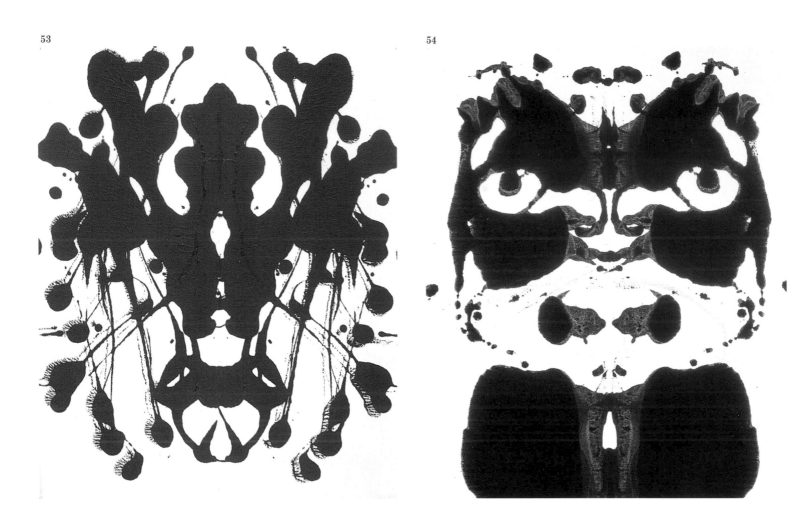

53, 54 Rorschach Painting, *1984; Rorschach Painting, 1984. This series of paintings is based on the cards of the Rorschach test, a method used by psychiatrists whereby a standard series of abstract ink-blots is presented to a patient who must then proceed to state what they suggest by establishing free associations. This underlying idea is reminiscent of the celebrated passage in Leonardo da Vinci's treatise* On Painting, *in which the Renaissance genius makes a reference to the suggestive power of inspiration that a spot on a wall can have for a painter.*

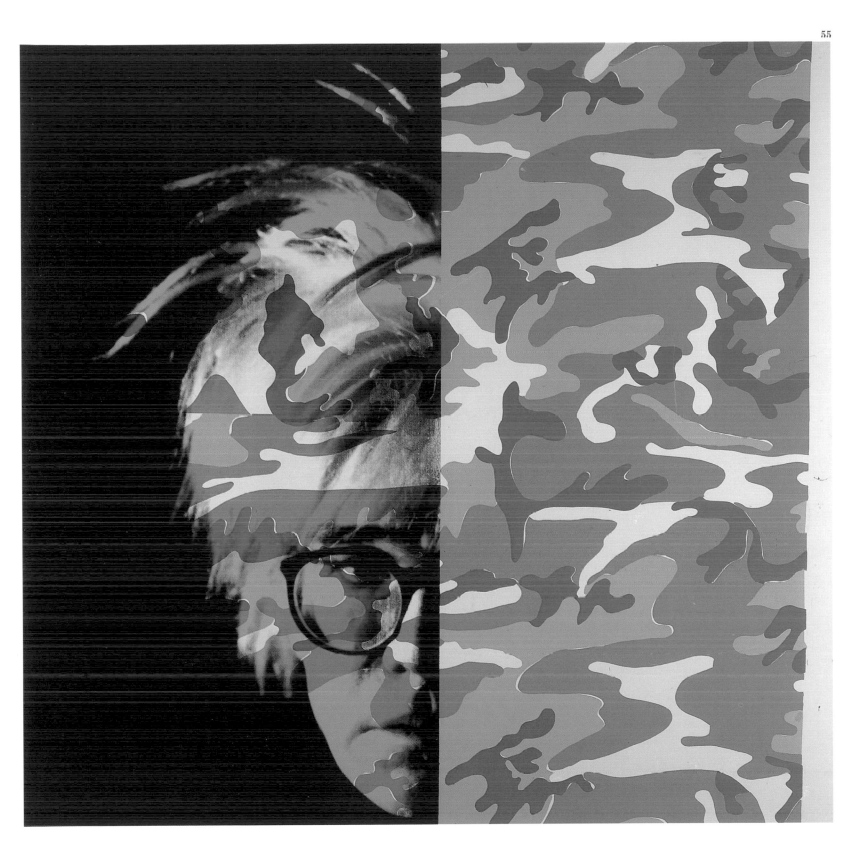

55 Camouflage Self-Portrait, *1986. Warhol produced self-portraits during the entire course of his artistic career. The narcissistic hero of this genre depicts himself with feigned modesty, assuming the roles of both viewer and object of spectacle, at once actor and spectator. The use of the military technique of camouflage—a heritage of his old fascination with disguises—successfully conceals and obscures more than ever the shy and evasive presence of the artist and his personality.*

List of Plates

1 A la Recherche du Shoe Perdu, *1955. Offset lithography, watercolor, and pen nib on paper, 26⅛ × 20" (66.4 × 50.8 cm). Andy Warhol Foundation for the Visual Arts, Inc.*

2 Untitled (Man Riding a Rooster), *c. 1957. Ink and gold leaf on paper, 20 × 14½" (50.8 × 36.2 cm). Private collection*

3 Babs, *1956. Ink, collage, and silver and gold leaf on paper, 12 × 16" (30.5 × 40.6 cm). Private collection*

4 Untitled (Unidentified Man), *c. 1957. Ink and gold leaf on paper, 20 × 16" (50.8 × 40.6 cm). Private collection*

5 Untitled (Cosmetics), *1962. Graphite, pastel, and photographic assemblage on paper, 38⅞ × 15½" (73.3 × 40.6 cm). Whereabouts unknown*

6 Before and After, *1960. Acrylic on canvas, 54 × 70" (137.2 × 177.8 cm)*

7 Superman, *1960. Acrylic and crayon on canvas, 67 × 52" (170 × 133 cm). Private collection, Paris*

8 Crossword Puzzle, *1960. Acrylic on canvas, 44⅜ × 63" (112.6 × 160 cm). Private collection*

9 Telephone, *1961. Acrylic and graphite on canvas, 72 × 54" (182.9 × 137.2 cm)*

10 Untitled (Hernia), *c. 1960–62. Acrylic on canvas, 54 × 72" (137.2 × 182.9 cm). Andy Warhol Museum, Pittsburgh. Founding Collection, contribution the Andy Warhol Foundation for the Visual Arts, Inc.*

11 Dance Diagram (Tango), *1962. Acrylic paint on canvas, 71½ × 52" (181.1 × 132.1 cm). Andy Warhol Museum, Pittsburgh. Founding Collection, contribution the Andy Warhol Foundation for the Visual Arts, Inc.*

12 210 Coca-Cola Bottles, *1962. Acrylic and silkscreen ink on canvas, 82 × 105" (208.3 × 266.7 cm). Private collection, Los Angeles*

13 Front and Back Dollar Bills, *1962. Silkscreen ink on canvas, two panels, each 83 × 19" (210.8 × 48.2 cm). Private collection, New York*

14 Big Campbell's Soup Can, 19 Cents, *1962. Acrylic and graphite on canvas, 72 × 54½" (182.9 × 138.4 cm). The Menil Collection, Houston*

15 Campbell's Soup Can, *1965. Acrylic and silkscreen ink on canvas, 35½ × 24" (90.4 × 61.6 cm)*

16 100 Campbell's Soup Cans, *1962. Acrylic on canvas, 72 × 52" (182.9 × 132.1 cm). Albright-Knox Art Gallery, Buffalo. Gift of Seymour H. Knox*

17 Brillo Box (Soap Pads), *1964. Silkscreen ink on wood, 17⅛ × 17⅛ × 14" (43.5 × 43.5 × 35.6 cm). Andy Warhol Foundation for the Visual Arts, Inc.*

18 Del Monte Box (Peach Halves), *1964. Silkscreen ink on wood, 9½ × 15 × 12" (24.1 × 38.1 × 30.5 cm). Andy Warhol Foundation for the Visual Arts, Inc.*

19 Various Boxes, *1964. Silkscreen ink on wood, varying dimensions*

20 Flowers, *1966. Acrylic and silkscreen ink on canvas, 40 × 40" (101.6 × 101.6 cm)*

21 Cow, *1966. Silkscreen ink on wallpaper, 45½ × 29¾" (115.5 × 75.6 cm)*

22 Five Deaths on Orange, *1963. Acrylic and silkscreen ink on canvas, 30 × 30" (76.2 × 76.2 cm)*

23 129 Die in Jet (Plane Crash), *1962. Acrylic on canvas, 100 × 72" (254 × 182.9 cm). Museum Ludwig, Cologne*

24 Car Crash, *1963. Acrylic and silkscreen ink on canvas, 105 × 81" (266.7 × 205.7 cm)*

25 Lavender Disaster, *1963. Acrylic and silkscreen ink on canvas, 106 × 82" (269.2 × 208 cm). The Menil Collection, Houston*

26 Suicide, *1963. Acrylic and silkscreen ink on canvas, 90 × 79" (228.6 × 200.7 cm)*

27 Tunafish Disaster, *1963. Acrylic and silkscreen ink on canvas, 41 × 22" (104.1 × 55.9 cm)*

28 Most Wanted Men, No. 2, John Victor G., *1964. Silkscreen ink on canvas, 48½ × 38⅝" (123.2 × 98.1 cm). Dia Art Foundation, New York*

29 Most Wanted Men, No. 2, John Victor G., *1964. Silkscreen ink on canvas, 48½ × 37" (123.2 × 94 cm). Dia Art Foundation, New York*

30 Small Race Riot, *1964. Acrylic and silkscreen ink on canvas, 30 × 33" (76.2 × 83.8 cm). Private Collection*

31 Atomic Bomb, *1965. Acrylic and silkscreen ink on canvas, 104 × 80½" (264.1 × 204.5 cm). Saatchi Collection, London*

32 Skull, *1976–77. Acrylic and silkscreen ink on canvas, 15 × 19" (38.1 × 48.3 cm)*

33 Skull, *1976–77. Acrylic and silkscreen ink on canvas, 15 × 19" (38.1 × 48.3 cm)*

34 Marilyn Monroe's Lips, *1962. Acrylic and silkscreen ink on canvas, two panels: 82¾ × 80¾" (210.2 × 205.1 cm); 83⅜ × 83" (211.8 × 210.8 cm). Hirshhorn Museum and Sculpture Garden, Smithsonian Institution, Washington, D.C. Gift of Joseph H. Hirshhorn*

35 Turquoise Marilyn, *1964. Acrylic on canvas, 40 × 40" (101.6 × 101.6 cm). Private Collection*

36 Marilyn Diptych, *1962. Acrylic and silkscreen ink on canvas, two panels, each 82 × 57" (208.3 × 144.8 cm). The Trustees of the Tate Gallery, London*

37 Triple Elvis, *1962. Silkscreen ink and aluminum paint on canvas, 82 × 60" (208.3 × 152.4 cm). Virginia Museum of Fine Arts, Richmond. Gift of Sydney and Francis Lewis*

38 Natalie, *1962. Silkscreen ink on canvas, 83½ × 91" (212.1 × 231.1 cm). Andy Warhol Museum, Pittsburgh. Founding Collection, contribution the Andy Warhol Foundation for the Visual Arts, Inc.*

39 Sixteen Jackies, *1964. Acrylic and silkscreen ink on canvas, overall 80 × 64" (203.2 × 162.6 cm). Walker Art Center, Minneapolis. Art Acquisition Fund*

40 Marlon Brando, *1966. Silkscreen ink on canvas, 41 × 47¼" (104.1 × 120 cm)*

41 Julia Warhola, *1974. Acrylic and silkscreen ink on canvas, 40 × 40" (101.6 × 101.6 cm). Andy Warhol Museum, Pittsburgh. Founding Collection, contribution the Andy Warhol Foundation for the Visual Arts, Inc.*

42 Truman Capote, *1979. Acrylic and silkscreen ink on canvas, 40 × 40" (101.6 × 101.6 cm). Dia Art Foundation, New York*

43 Ladies and Gentlemen, *1975. Acrylic and silkscreen ink on canvas, 14 × 11" (35.6 × 27.9 cm). Andy Warhol Museum, Pittsburgh. Founding Collection, contribution the Andy Warhol Foundation for the Visual Arts, Inc.*

44 Ladies and Gentlemen, *1975. Acrylic and silkscreen ink on canvas, 14 × 11" (35.6 × 27.9 cm). Andy Warhol Foundation for the Visual Arts, Inc.*

45 Mao, *1973. Acrylic and silkscreen ink on canvas, 12 × 10" (30.5 × 25.4 cm)*

46 Mao, *1973. Acrylic and silkscreen ink on canvas, 26 × 22" (66 × 55.9 cm)*

47 Oxidation Painting, *1978. Mixed mediums on canvas, 40 × 30" (101.6 × 76.2 cm). Andy Warhol Foundation for the Visual Arts, Inc.*

48 Oxidation Painting, *1978. Mixed mediums on canvas, 40 × 30" (101.6 × 76.2 cm). Andy Warhol Foundation for the Visual Arts, Inc.*

49 Joseph Beuys, *1980. Silkscreen ink on paper with diamond dust, 44 × 30" (111.8 × 76.2 cm)*

50 Sixty Last Suppers, *1986. Acrylic and silkscreen ink on canvas, 9'8" × 32'4" (294.6 × 998.2 cm). Leo Castelli Gallery, New York*

51 Close Cover Before Striking, *1962. Acrylic, Prestype, and sandpaper on canvas, 16 × 20" (40.6 × 50.8 cm)*

52 The Disquieting Muses (After De Chirico), *1982. Acrylic and silkscreen ink on canvas, 50 × 42" (127 × 106.7 cm). Andy Warhol Foundation for the Visual Arts, Inc.*

53 Rorschach Painting, *1984. Acrylic on canvas, 20 × 16" (50.8 × 40.6 cm)*

54 Rorschach Painting, *1984. Acrylic on canvas, 20 × 16" (50.8 × 40.6 cm)*

55 Camouflage Self-Portrait, *1986. Acrylic and silkscreen ink on canvas, 80 × 80" (203.2 × 203.2 cm)*

Selected Bibliography

Alloway, Lawrence. *American Pop Art.* New York: Collier Books in association with the Whitney Museum of American Art, 1974.

Andy Warhol Collection, The: Sold for the Benefit of the Andy Warhol Foundation for the Visual Arts. 6 vols. New York: Sotheby's, 1988.

Andy Warhol: Death and Disasters. Houston: Menil Collection and Houston Fine Arts Press, 1988.

Bockris, Victor. *The Life and Death of Andy Warhol.* New York: Bantam Books, 1989.

Bourdon, David. *Warhol.* New York: Abrams, 1989.

Crone, Rainer. *Andy Warhol.* New York: Praeger, 1970.

McShine, Kynaston, editor. *Andy Warhol: A Retrospective.* New York: The Museum of Modern Art, 1989.

Ratcliff, Carter. *Andy Warhol.* New York: Abbeville Press, 1983.

Warhol, Andy. *The Philosophy of Andy Warhol (From A to B and Back Again).* New York: Harcourt Brace Jovanovich, 1975.

Warhol, Andy, and Pat Hackett. *POPism: The Warhol Sixties.* New York: Harcourt Brace Jovanovich, 1980.

Series Coordinator, English-language edition: Ellen Rosefsky Cohen
Editor, English-language edition: Beverly Fazio Herter
Designer, English-language edition: Judith Michael

Page 1 One-Dollar Bill with George Washington's Portrait, *1962.*
Pencil on paper, 17¾ × 23⅝" (45 × 60 cm). Private collection

Library of Congress Catalog Card Number: 97–70934
ISBN 0–8109–4655–6

Printed and bound in Spain by Filabo, S.A.
Sant Joan Despí (Barcelona)
Dep. Leg.: B. 15.350 – 1997